KLEINE WELT
Dieter Roelstraete

Neubauer Collegium Exhibitions

Contents

David Schutter
Drawing Boards, 2019
Woodcut

Preface
Dieter Roelstraete

The books are not yet on the shelves,
not yet touched by the mild boredom of order.
Walter Benjamin, "Unpacking My Library"

This project – an exhibition *cum* publication – is rooted in a twofold observation that recurs every time I pack and unpack my library. First, why do authors and/or publishers in the field of twentieth-century philosophy and capital-T Theory so often turn to Paul Klee – indeed, often even the same Paul Klee painting, over and over again – to adorn the covers of their books? And second, are the authors and publishers who put Caspar David Friedrich's iconic *Wanderer Above the Sea of Mists* on the covers of their books ever aware of how many authors and/or publishers have done the exact same thing before them?

Many of the books whose cover art is reproduced in this catalogue are taken from my personal library, none of which were bought because of the images gracing their covers – although I do pay scrupulous attention to the art of theory-bound book design. Some of the covers reproduced in this publication *do* belong to books bought simply because they sport either a Klee drawing or painting or Friedrich's *Wanderer.* They are the result of a necessarily incomplete search that could have gone on forever: I am quite sure there are hundreds of books out there with Klee covers that escaped my attention. (Two internal rules governed the selection of said books: English-language titles only, and no books "about" Klee or Friedrich.)

This is emphatically *not* a project about the visual poverty of the publishing imagination in said philosophical fields – I do not mean to ridicule the tastes, instincts, and biases of the philosophy/theory publishing business. Yet there is inevitably something humorous about seeing Klee's *Angelus Novus*, say, turn up on book cover after book cover, all more or less directly related to the matter of German philosophy, German-Jewish philosophy, and/or Jewish philosophy; of mourning, memory, and melancholia. This is a testament, of course, to the sheer power of the image in question – the same is true of Friedrich's *Wanderer* – and to the singular force of Klee's imagery in particular, its undying appeal to the world of thoughtful, inquisitive readers. Which raises the question: What, precisely, powers this force? *Why Klee?*

On a more fundamental level, then, this is a project about the power of the image, of a select handful of images, and its spellbinding grip on one strand of the twentieth century's intellectual imagination above all. The power of these images is such that they seem effortlessly to withstand even the crassest and crudest forms of recycling – I'm thinking of Friedrich's *Wanderer* in particular here, endlessly repurposed for cheap advertising objectives or graphic gamesmanship. I am interested, in short, in these images' *afterlife* – the ease with which they have entered the stream of our intellectual consciousness and smoothly sail from one point of anchorage to another. This book of book covers, then, is an ode to the power held by these specific images over a discipline of the mind that often fancies itself impervious to the lure and surface charm of the world of "pictures," and often likes to think of itself as above and beyond imaging. Not so.

The current book is divided between Friedrich and Klee, so to speak. A photographic sequence of Klee-toting book covers, complete with extensive annotations on the relationship between the Klee work and the book in question, is bracketed by a short text by Neubauer Collegium Roman Faculty Director Jonathan Lear (whose

own book *Open Minded* sports a late Klee painting on its cover) and an essay by the Heidegger scholar Dennis J. Schmidt, who has long considered Klee's impact on the landscape of twentieth-century philosophy. A series of photographs of book covers showing Friedrich's classic of Northern Romanticism is bookended by a conversation between artists Zachary Cahill and Hans Haacke, both committed Friedrich aficionados, and a reprint of a wide-ranging, properly rambling essay written by the undersigned in 2012 on the subject of the *Wanderer*. A text by Susan Bielstein of the University of Chicago Press – which has published its fair share of Klee covers – provides a valuable insider perspective on the vagaries of philosophical-theoretical book design.

Fittingly, the cover of this book is graced with a Paul Klee etching titled *Kleine Welt*, or "Little World," which gave the project its name: a microcosm of creepy-crawly movement invoking the small world of the writers, makers, and readers of books: a lovers' *kleine Welt*.

Chicago, October 2018

On the Cover
Jonathan Lear

When we give the advice *don't judge a book by its cover* we are almost never talking about books and covers. No, the books are us. We use the phrase to encourage or warn family and friends about another human being – one whom we are getting to know. The remark comes as an intervention. I am put off by someone's mannerism and a friend urges me to move beyond that; or, I am infatuated by a person's charm and a friend warns me that he is untrustworthy. The advice appeals to our primordial philosophical natures: our felt need to move from appearance to reality. It says a lot about our intimacy with books that it is so easy to portray ourselves, *our inner reality*, in terms of being a book; and our self-presentation, whether truthful or not, in terms of being a cover.

Might there come a time when this advice becomes unintelligible? People say books might become things of the past. My intuitions run in a contrary direction. As artifacts go, books are perfect. Our yearning for meaning encounters this worldly form and, when things go well, nothing is missing. And thus, books having come into the world, I suspect they will never exit. Of course I might be mistaken. But of this I am confident: Should there arise future generations who live without books, there will be so much about us they will not be able to understand. So many of our pleasures will be beyond their ken.

Such as: What does a cover mean to the author of a book? There are myriad answers to this question and I shall only describe my experience. Although I am surrounded by family and friends, when I am writing I am more or less alone with my thoughts. Perhaps because I live on the edge of a mighty expanse of water, my mind wanders in a Crusoe-like direction. When I send off a manuscript it feels like I am *letting it go* – to drift off in a bottle to who knows where. I feel the excitement and anticipation of intimacy with a stranger. Will this book find a reader? A reader: someone for whom the book will strike a chord, someone who will read it with sympathetic imagination, someone who will be triggered to go on thinking for him- or herself. When author and book and reader come together in that way, the world lights up with a tiny burst of like-mindedness. No narrative of rocks and ice, darkness and distance, atoms and void, can take this moment of generosity away from the universe. This is a form of connectedness between people whom, in other ways, might not know each other at all. Where will the book go? Whom might it find? And will I come to know anything of the journeys this book will have?

It is in the context of these wonderings that, miraculously, a bottle washes back up on my shore. In it is my manuscript and one additional page, a long page with front and back and spine that is the prospective cover of my book. I know of no better proof of intelligent life in the universe. Someone I do not know has read the book and then deployed artistic judgment to choose a painting that expresses – in a different form – the meaning of the book as a whole. What a gift – and we have never met. The image is meant to be alluring, to draw the reader in. I do not know how to do this. And so – except on one occasion when I was disappointed – I am struck, delighted and humbled by the creativity of another person, with a different sensibility, deploying his or her talents on behalf of this book. Obviously, in the course of writing a book I give lectures, try out ideas in seminars; my wife, friends,

and colleagues read drafts and offer comments; and so on. Still, the cover is the first response I get from the world after I have *let go*.

Poets regularly render images in words. A book-cover designer's *poiêsis* moves in the opposite direction. It moves from another person's words – in this case, mine – to an image. More than that. The image is of an established work of art – and so the cover is a first weaving of my book into a larger cultural fabric. And then there is the typography. The cover is the place image *meets* words. What is the font for the title? How will it be placed with respect to the image? What if there is a colon? Where will the subtitle go? And the letters themselves: Will they be colored or black or white – and how saturated with ink, how brilliant, will the typeface be? All these juxtapositions create a microcosm of meaning that no one may yet understand.

Of course, the whole process might fall apart. Perhaps the designer is a hack. Perhaps the choice has been disfigured by commercial factors. But when the process works a new unity is created: book and cover working together, *being a book*. When that happens the cover becomes at once an expression of the meaning of the book and an invitation to the approaching reader: *behold me thus!* And yet, the *thus* is typically enigmatic. The beholder grasps in the same act of consciousness that the book is to be understood *in this way* and that it is not clear what this way amounts to. Aristotle called this *aporia*; the psychoanalyst Jean Laplanche called it seduction. The opportunity opens for author and publisher and designer and readers to create a *small world – eine kleine Welt –* of shared understandings and meanings and insights, as well as of disagreements, alternatives, disruptions, and exciting confusions. A small world of goings-on. It is this lighting up of the universe that the current exhibition explores.

Jonathan Lear is the Roman Family Director at the Neubauer Collegium for Culture and Society.

Kleeblätter

A Selection of Annotated Book Covers

Dieter Roelstraete

The following chapter highlights Paul Klee's enduring popularity as the academic and semi-academic publishing world's premier purveyor of sufficiently "philosophical" imagery: a sequence of forty-one book covers accompanied by explanatory commentary dwelling on the artwork on the cover, the contents of the book in question, and the presumed or potential relationship between the two. The books, photographed by Assaf Evron, are ordered in accordance with the chronology of Klee's work. Taken together, the annotations attempt to shed some light on the reasons why Klee's work has proven so alluring to the twentieth-century philosophical imagination (especially of the so-called "continental" variety). The overarching reason, however, may be found in Klee's exemplary wedding of the visible and the legible. As the art historian Annie Bourneuf put it in her study of this exact union, *Paul Klee: The Visible and the Legible*, "the pursuit of analogies between writing and images, the solicitation of a reading-like mode of viewing," are central to Klee's art. He is, in short, the philosopher's painter, bringing the verbose world of thought to chattering visual life.

BREAKING THE SPELL

Religion as a Natural Phenomenon

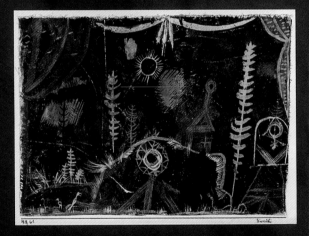

DANIEL C. DENNETT

AUTHOR OF *Darwin's Dangerous Idea*

I read a quote a few years ago by Gershom Scholem,
historian of Jewish mysticism. He wrote, "The image
escapes in every direction." I believe that to be true.
R. H. Quaytman

Einsiedelei

(*Hermitage*), 1918

Zentrum Paul Klee, Bern

Daniel C. Dennett

Breaking the Spell

Viking, 2006

MARTHA B. HELFER

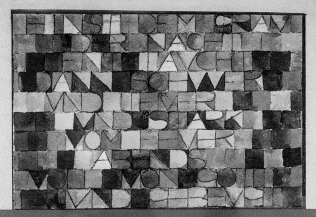

THE WORD UNHEARD

Legacies of Anti-Semitism in German Literature and Culture

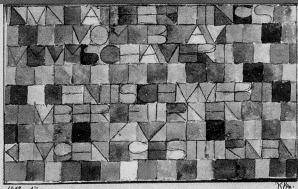

1918 17

This is the first of many examples of the centrality of Paul Klee's iconography to the visual imagination of twentieth-century German-Jewish thought. The cover of this book by Martha B. Helfer shows Klee's *Einst dem Grau der Nacht enttaucht... (Once Emerged from the Gray of Night...)*, a visual poem composed in 1918. Helfer's *The Word Unheard* considers "legacies of anti-Semitism in German literature and culture," as the subtitle puts it, and centrally revolves around the notion of *latency*: "Through rigorous close readings [of works by Friedrich Schiller, Adalbert Stifter, Franz Grillparzer, and others] it presents a method for analyzing how latent discourses of anti-Semitism construct meaning in the literary text." Helfer answers the question of latency in a literary text by way of Klee's typographic drawing (otherwise thematically unrelated to the topic of this book, as Helfer admits – no risk-free acknowledgment): "As a graphic illustration of how a work can hide a latent subtext conspicuously in plain view, a latent subtext that deliberately draws attention to itself and demands to be read, consider Paul Klee's *Once Emerged from the Gray of Night... (Einst dem Grau der Nacht enttaucht...*, 1918). The painting, reproduced here and in color on the book jacket, is visually stunning. With its robust interplay of colors and forms, the painting attracts the viewer's gaze; the eye lingers on the dynamic beauty of this visual image. So much so, in fact, that it is very easy to miss a seminal feature of the artwork: embedded in this complex visual image is a poem." Klee most likely composed the poem himself:

Once emerged from the gray of night
Heavier and dearer and stronger
Than the fire of the night
Drunk with God and doubled over.
At present ethereal
Surrounded by blue
Soaring over the glaciers
Towards the wise constellations.

Klee's interest in the visual power of poetry first acquired substance in a cycle of six watercolors dating from 1916 based on a sampling of Chinese poems – Chinese poetry was experiencing a rush of high esteem in the West at the time (consider Ezra Pound's Cathay anthology of classical Chinese poetry, published in 1915, for instance). In his well-known "Creative Credo" from 1920, Klee declared: "In the beginning is the act; yes, but above it is the idea. And since infinity has no definite beginning, but is circular and beginningless, the idea may be regarded as the more basic. In the beginning was the word, as Luther translated it." Which – Luther's own vicious, baleful anti-Semitism notwithstanding – clearly aligns Klee with a distinctly "Hebraic" undercurrent in Western thought, an intuition seized upon most consequentially by Walter Benjamin.

Einst dem Grau der Nacht enttaucht...

(Once Emerged from the Gray of Night...), 1918

Zentrum Paul Klee, Bern

Martha B. Helfer

The Word Unheard

Northwestern University Press, 2011

Walter
Benjamin
An Aesthetic of Redemption

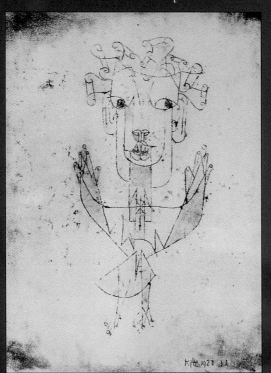

RICHARD WOLIN

Angelus Novus has become the symbol par excellence, it seems, of the triumphs and tragedies of twentieth-century German-Jewish culture and philosophy. This quirky little oil-transfer drawing, made by Klee in 1920 – in between his dismissal from wartime military service and his appointment at the Bauhaus – and now owned by the Israel Museum in Jerusalem, is of course best known through its association with the work of Walter Benjamin, who bought it from a Munich art dealer named Hans Goltz for the tidy sum of 1,000 marks in late spring 1921. (Already in 1920, Benjamin's wife, Dora, had given her husband a Klee drawing as a birthday present, namely the gouache *Introducing the Miracle* from 1916, now in the collection of the Museum of Modern Art in New York. I do not know of any books that have that particular Klee work on their cover.) That same year, Benjamin founded a literary journal titled *Angelus Novus*, framing it as an "attempt to draw a connection between the artistic avant-garde of the period and the Talmudic legend about angels who are being constantly created and find an abode in the fragments of the present." (Klee was not Jewish, and would likely have been bemused by Benjamin's Talmudic reading; the two never met, and we do not know what Klee thought – if anything – of Benjamin's interpretation of this youthful work.) Klee's whimsical winged creature clearly ranked among Benjamin's most prized possessions, keeping the German-Jewish philosopher company throughout his nomadic, tragically short life. Shortly before fleeing Paris in the summer of 1940 on his way to the small Pyrenean border town of Port Bou, where he would meet his chosen end, he included Klee's seraph in a cache of papers entrusted to a librarian at his beloved Bibliothèque Nationale called Georges Bataille. After the war, Benjamin's possessions were somehow passed on to his Frankfurt School colleague Theodor Adorno in New York, who later transferred them to Benjamin's Weimar-era friend Gershom Scholem, the revered historian of Jewish mysticism in Israel. (It is not clear whether what has been referred to as a *reproduction* of *Angelus Novus* as one of the few ornamental items on display in Theodor and Gretel Adorno's house back in Frankfurt after the war was actually the *real*, fully auratic thing. Scholem had been named Benjamin's legal heir in a testament drawn up as early as 1932.) After Scholem's death in 1982, Klee's monotype was finally gifted by the former's widow to the Israel Museum in 1987 – resulting in the first public viewing in sixty-six years of a work only known, until then, through its enigmatic invocation in the ninth paragraph of Benjamin's abstruse testament "Theses on the Philosophy of History" (1940).

 Angelus Novus as Benjamin's personal guardian angel, sure – but what about reading it as a (self-) *portrait* of Benjamin first and foremost – a mirror image of the philosopher so keenly aware of, indeed spellbound by, "the strange interplay between reactionary theory and revolutionary practice"? Let us look back, more closely than the Benjaminians, so often blinded by devotion, are customarily inclined to do, at Klee's work (not a painting! and poorly reproduced on the cover of this Benjamin inquest too!): Does the buck-toothed angel have hair made out of *scrolls*?

Angelus Novus, 1920

The Israel Museum, Jerusalem

Richard Wolin

Walter Benjamin

University of California Press, 1994

Baroque
Reason

*The Aesthetics
of Modernity*

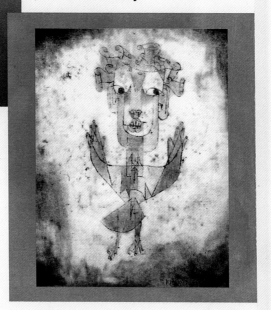

Christine
Buci-Glucksmann

In this book – an influential early chapter (it was originally published in French in 1984, with Gustav Klimt's *Salome* on the cover) in the evolving history of Walter Benjamin's association with Klee's *Angelus Novus* – the Parisian philosopher Christine Buci-Glucksmann calls the theme and the allegory of the Angel the German-Jewish philosopher's "personal cipher":

> The starting-point is an encounter like any other: impact, brainstorm, post-shock. On 21 June Benjamin bought a picture by Klee called *Angelus Novus*. It was love at first sight for this half-ironic, half-enigmatic 'new angel' with a floating, dreamy sexuality, its wide-open eyes staring into the distance and its hair curled in the form of (somewhat baroque) parchments. Klee was particularly fond of these intermediate creatures, and of the many paintings he devoted to them *Angelus Novus* is certainly not among the greatest. Yet, as we know from Scholem, who would himself later write a poem to the Angel, 'Benjamin always considered the picture his most important possession'. On 23 July 1920, in connection with another painting by Klee, *Seduction by the Miracle* [Buci-Glucksmann is referring to *Introducing the Miracle* here], he wrote to Scholem: 'Do you know Klee? I like him enormously.'
>
> Benjamin never lost this fascination with Klee, and with a picture that one would hardly hesitate to call a 'collage-object', juxtaposing as it does the most disparate aspects of the parental images. He kept it hanging at home until his divorce, and remained unable to part with it except through death. It even followed him into exile at rue Dombasle in Paris, thanks to an acquaintance who got it across the border, and in the dark hours of the war it was finally hidden by Georges Bataille at the Bibliothèque Nationale before being forwarded to his friend Scholem. The *Kleeblatt* (which also means cloverleaf in German) was immediately caught in a web of signifiers, evoking the celestial clover as symbol of the Trinity.

Towards the end of his life (Klee passed away in Bern on June 29, 1940, a mere three months before Benjamin, elsewhere), Klee returned to the graphic motif of heaven's winged creature – now much coarsened and simplified by the onset of scleroderma – on numerous occasions. All around, meantime, the Angel of History had taken on a truly demonic, *satanic* cast, its wings now fanning the fateful fire in which modernity's "baroque reason" was about to consume itself – the angel turned *hysteric*.

Angelus Novus, 1920
The Israel Museum, Jerusalem

Christine Buci-Glucksmann
Baroque Reason
SAGE Publications, 1994

THE FRANKFURT SCHOOL REVISITED

AND OTHER ESSAYS ON POLITICS AND SOCIETY

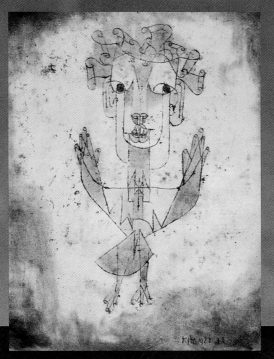

RICHARD WOLIN

This is the second book by Richard Wolin in our collection sporting Benjamin's Angel of History on its cover. Three other books by Wolin, all of which revolve around Martin Heidegger and his philosophical legacy, have Giorgio de Chirico covers. To a certain extent, the figure and work of Paul Klee in our research could easily have been replaced with that of either de Chirico or René Magritte, whose imagery has likewise thrived tremendously in the "theory" publishing business these last few decades.

Here, at long last, is the paragraph from Benjamin's "Theses on the Philosophy of History" that made Klee's angel a household name:

> A Klee painting named "Angelus Novus" shows an angel looking as though he is about to move away from something he is fixedly contemplating. His eyes are staring, his mouth is open, his wings are spread. This is how one pictures the angel of history. His face is turned toward the past. Where we perceive a chain of events, he sees one single catastrophe which keeps piling wreckage and hurls it in front of his feet. The angel would like to stay, awaken the dead, and make whole what has been smashed. But a storm is blowing in from Paradise; it has got caught in his wings with such a violence that the angel can no longer close them. The storm irresistibly propels him into the future to which his back is turned, while the pile of debris before him grows skyward. This storm is what we call progress.

We already know that Benjamin never met Klee, and there is no way of knowing whether Klee was ever made aware of Benjamin's expansive interpretation of what the artist may well have considered to be a minor work, shown in Munich in the early 1920s alongside more ambitiously scaled abstract paintings. (Benjamin and Klee both died in 1940, the year the "Theses on the Philosophy of History" were conceived – but not published: a twenty-year rift between production and reception to *begin with*.) What is more, neither Benjamin nor the ever-widening delta of Benjamin exegesis ever bothered to wonder, it seems, what Klee meant when making this drawing. And according to Carl Djerassi, author of *Four Jews on Parnassus – A Conversation: Benjamin, Adorno, Scholem, Schönberg*, "J.K. Eberlein's book *Angelus Novus: Paul Klees Bild und Walter Benjamins Deutung* concludes on historical grounds that Klee had meant Hitler." It is true that it was in Munich in early 1920 that Hitler first came to full-blown national attention, thanks to the de facto founding of the NSDAP through the so-called 25 Point Party Program. Klee, as a denizen of the Schwabing bohème, may have been aware of the rising star of German reaction – though Eberlein's conjecture remains something of a stretch. However it may be, a *demon* of history seems a much more fitting totem animal for the perennially apocalyptic *humeur* of the Frankfurt gnostics than a bird-footed prankster with little in the way of angelic wings. Also, which wreckage exactly?

Richard Wolin

The Frankfurt School Revisited

Routledge, 2006

Angelus Novus, 1920

The Israel Museum, Jerusalem

The Rupture with Memory

Derrida and the Specters that Haunt Marxism

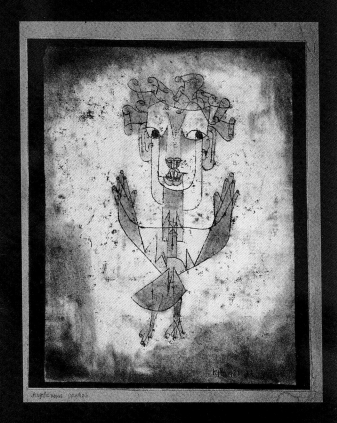

Nissim Mannathukkaren

How far the Angel flies!

The central claim of this brief treatise, published by the independent "anti-caste" imprint Navayana in New Delhi, on the recent history of communist theory, is that it would be a perilous mistake for "the" Marxists to dismiss Jacques Derrida's highly influential (in some quarters) *Spectres of Marx* as a mere work of deconstruction/poststructuralism. "Post 9/11, the Marxist project needs to engage more creatively not only with Derrida but also others like Benjamin, Bloch and Marcuse to rebuild strategies to mount a challenge to the evangelical neo-liberal hegemony and to other religious fundamentalisms," Mannathukkaren writes. "The imperative for this should come from the desire to reinstate the 'romantic' Marx… into the Marxist oeuvre." It is this "romantic" Marx, haunted by occasional doubts about the actual direction of the march of time, that propels the Angel of History whose reluctant wings are caught in the storm of progress – a properly melancholy Marxism. Mannathukkaren, a Keralan historian of leftist ideas, derives the title of his book from the following passage by Antonio Negri, quoted here as proof of the persistent problem of Marxist amnesia: "The person who fights or has fought for communism is certainly not nostalgic for the old organizations, neither the Stalinist one, nor the folkloric one that survives on its fringes. The new communist experiment is born through *the rupture with memory*. A rupture distinct from any melancholy or resentment" – painfully paradoxical proof, in short, that "what has gained hegemony under (capitalist) modernity" is a "culture of forgetting – i.e. one based on erasure and exaggerated notions of obsolescence" rather than a "culture of remembering." Long-running doubts about the depth of Benjamin's commitment to Marxism notwithstanding, it is precisely to his theological inclinations – the Jewish mystic praying before his *Angelus Novus* – that we must turn to keep the Marxian specter alive. Mannathukkaren turns to Herbert Marcuse to single out art as a particularly powerful tool in this secular theology: "Art fights reification by making the petrified world speak, sing, perhaps dance. Forgetting past suffering and past joy alleviates life under a repressive reality principle. In contrast, remembrance spurs the drive for the conquest of suffering and the permanence of joy."

The closest Klee ever came to unreservedly embracing the communist gospel was when he was living in Munich, capital of the short-lived Bavarian Soviet Republic of 1918–19. A self-proclaimed revolutionary rather than democrat, he responded to an invitation from the painter Fritz Schaefler to join the artists' advisory council of the Räterepublik in the following terms: "The Action Committee of Revolutionary Artists may completely dispose of my artistic capabilities. It is a matter of course that I regard myself as belonging here, since, after all, already several years before the war I was producing in the manner which now is to be placed on a broader public foundation." Klee later looked back on the Munich Soviet experience in the unchanged conviction that "the part of us which aims for eternal values would be better supported in a Communist community." The Angel leers left.

Nissim Mannathukkaren

Angelus Novus, 1920 *The Rupture with Memory*

The Israel Museum, Jerusalem Navayana Publishers, 2011

GERMAN-JEWISH THOUGHT
AND
ITS AFTERLIFE

A TENUOUS LEGACY

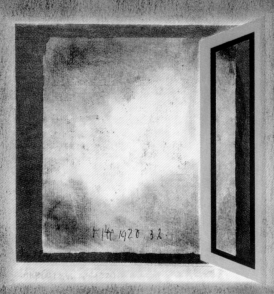

VIVIAN LISKA

Liska is the exception to the general rule of authorial disregard for, or disinterest in, the face an author's book ends up having – Which cover image do we choose to do the monumentally important work (I think) of capturing a potentially interested book-buying party's attention? As she explains in the first paragraph of *German-Jewish Thought and Its Afterlife*: "The book cover features a painting by the US artist Rebecca H. Quaytman that evokes Paul Klee's *Angelus Novus* and, with it, the ultimate icon of German-Jewish thought, Walter Benjamin's Angel of History. The background of Klee's *Angelus* is still recognizable in Quaytman's painting, but the angel has vanished. The painting jolts our visual memory into projecting the angelic figure onto the voided surface and invites us to imagine the angel's flight. Like the departure of the owl of Minerva, the absent angel indicates that a form of life – in Hegel's words *eine Gestalt des Lebens* – is about to disappear."

This introductory remark hardly honors the true complexity of Quaytman's work – which here, of course, only functions as a cover image after all, undeserving, perhaps, of proper philosophical scrutiny. The painting in question depicts a brown patch or parchment-like surface, hemmed in to the right by a slanted blue frame, like a window thrown open to reveal the picture's innards. A closer look reveals Klee's scrawly signature, a date ("1920"), and underneath, only half legible, a title: "Angelus Novus." It is one of a series of works that together constitutes "Chapter 29" of Quaytman's methodically unfolding *oeuvre*, the title of which includes the Hebrew word חקק (*haqaq*), meaning both "to engrave" as well as "to legislate." For this work, which premiered at the Tel Aviv Museum of Art in 2015, the artist spent long hours investigating Klee's emblematic angel, which she discovered was in fact "drawn" atop an old copper plate engraving. Quaytman recalls: "After experiencing a familiar combination of shyness and repulsion towards this image, so weighed down by history as it is, my focus naturally scurried back to the materiality of the artifact. I instantly noticed around all four sides, an old engraving, discernible to the naked eye. An obscure old engraving, so devalued that no one had even noticed it. Clearly visible were the overlapping initials CL, a date... and black pleats from a gown suggesting a portrait of a priest, nun, or monk. I asked what was known about it and who was depicted in the engraving. To the astonishment of us all, it turned out that they didn't know, because the question seemed never to have been asked." Weeks later, the print behind one of modern art's most iconic and best-loved images was finally unearthed: an engraved portrait of none other than Martin Luther – the architect of the Reformation and progenitor of an especially German, especially vicious brand of anti-Semitism.

Somewhat surprisingly, perhaps, Luther hardly features in Liska's account of the "tenuous legacy" of German-Jewish culture and thought. Her book does conclude, however, with an insightful overview of recent discussions of Benjamin's Angel of History, reminding us that in Slavoj Žižek's interpretation of Klee's monotype, the angelic figure should be understood as a portrait of Jesus Christ.

Vivian Liska

R. H. Quaytman *German-Jewish Thought and Its Afterlife*
חקק, Chapter 29, 2015 Indiana University Press, 2017

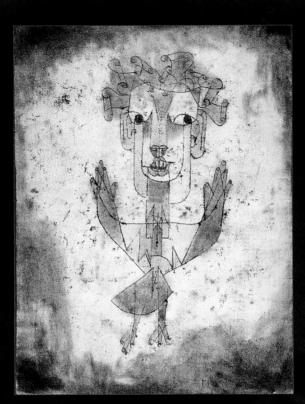

THE SENTIENT ARCHIVE

BODIES, PERFORMANCE, AND MEMORY

EDITED BY BILL BISSELL AND LINDA CARUSO HAVILAND

The odd one out: What does Klee's *Angelus Novus* have to do with bodies and/or performance? Oh, right – *memory*, as the subtitle of this reader subtly avers (and the body as an archive of memories). Still, this is undoubtedly a stretch: "This reverberating partnership between historical storm and the fleeting witness of its wreckage turns the angel from delivery person, perfect servant, or passive carrier of someone else's message into a new kind of dancer. His body stands as the fibrillating membrane of historical experience, both border and articulator of past, present and future. The angel of history dances the impossible sutures and constitutive ruptures of historical time." (This is a quote from an essay by André Lepecki titled "Choreographic Angelology." The essay begins with a Friedrich Schiller quote: "I know of no better image for the ideal of a beautiful society than a well-executed English dance, composed of many complicated figures and turns.") The Angel of History as a *dancer* – this is certainly a novel, unusual approach, teasing out the Angel's subdued musicality, imagining the flapping of its wings to sketch out a choreography for the future, of sorts.

I can imagine Klee getting up for a modest shuffling of the feet every now and then, but *Benjamin*? His most exhaustive and discerning biographers reminisce: "Although we have no record of his first encounter with the little picture [*Angelus Novus*], Charlotte Wolff's recollection of Benjamin's delight at an unexpected discovery gives some sense of the animation that could overcome this otherwise 'gauche and inhibited man': he 'behaved as if something marvelous had been given to him.'" Sometime in 1921, Gershom Scholem – in whose Munich apartment Klee's angel was temporarily housed upon Benjamin's acquisition of the work – sent a poetic meditation on the *Angelus Novus* to his friend Benjamin on the occasion of the latter's birthday; it concludes on the following note: "I am an unsymbolic thing / and signify what I am / you turn the magic ring in vain / for I have no meaning."

Angelus Novus, 1920

The Israel Museum, Jerusalem

Bill Bissell and Linda Caruso Haviland (eds.)

The Sentient Archive

Wesleyan University Press, 2018

GERMAN PHILOSOPHY IN THE TWENTIETH CENTURY

Weber to Heidegger

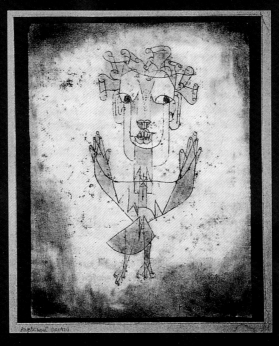

JULIAN YOUNG

The one thing I found noteworthy about this volume – really a coursebook – is the absence and omission of Walter Benjamin. This is a little odd for a book adorned with the very logo of Benjamin's thought, so to speak. Granted, in the author's introduction, we are promised a second installment of a two-part critical engagement with modern and contemporary German philosophical history that will include Benjamin. Along with "Carl Schmidt" (*sic*), among others. Will that volume have a Giorgio de Chirico painting on its cover?

The use of Benjamin's art-historical alias on the cover of a book that does not even mention him – and that does not dwell in any commanding depth on the "tangled legacy" of German philosophy's Jewish shadow – does prompt intimations of the unsayable, however, at the risk of philosophical blasphemy: Is Walter Benjamin *overrated*? Is the theorist of fragmentation and master of the fragment the ideal bard for our hopelessly fragmented world – and, for those among us who expect their philosophy to be totalizing in intent, therefore fundamentally a *minor* figure in the history of Western thought? The Angel of History, in Benjamin's interpretation, hovers over the wreckage of the present time – fragments, remains, ruins. He is the patron saint of all that is broken, disjointed, *small*. This inevitably makes Klee the artist of his choice – the chronicler par excellence of late-twentieth-century culture's love affair with the minute and microscopic, the footnote, the detail, and the anecdote. Klee is the painter of smallness and minutiae (it is hard to imagine his work "illustrating" the sweeping megalomaniacal statements of Hegelian system-building, and I know of no studies of Hegel that have a Klee painting on their cover): a giant of lower-case art, of the minor as both a philosophical and aesthetic position. In other words still: He is the painter of the small world – the *Kleine Welt* after which this project is named – that the landscape of twentieth-century thought, huddling under the angel's wings, has become.

Julian Young

Angelus Novus, 1920

German Philosophy in the Twentieth Century

The Israel Museum, Jerusalem

Routledge, 2018

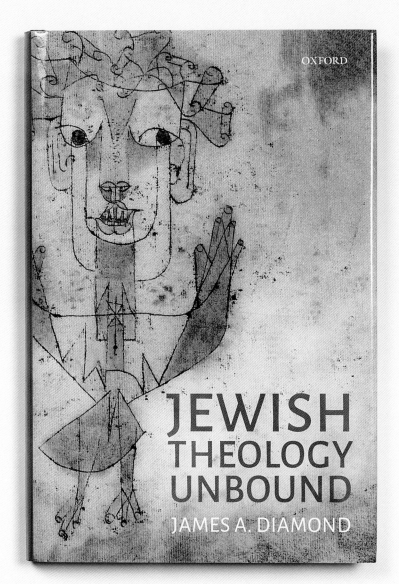

JEWISH
THEOLOGY
UNBOUND

JAMES A. DIAMOND

Another very recent find – I came across this book while unthinkingly perusing the Oxford University Press catalogue for Judaica titles. And there it was, of course. *Angelus Novus* truly represents Klee unbound – or, rather, bound, like an angel in mid-flight, for ceaseless recycling.

After so many readings, astonishingly, there is still more to discover in this bottomless image (though typically, of course, always in a postscript – the following quote is lifted from the book's penultimate page):

> Benjamin's angel [whose angel is it anyway?] attests to a long history of civilization's refusal to listen to the metaphysics of the angelic encounter. Trapped in a temporal flow of "progress" that is measured by utility, the more it advances, the more destruction it leaves behind, because it is not informed by that which transcends time. It cannot really advance without reaching back to the divine view of the creation and Paradise in its pristine state. The "debris" that has accumulated as a result threatens to permanently obstruct the "goodness" inherent in the creation as declared by God and render the message of the biblical angelic encounter irretrievable. Because the angel's wings are no longer functional, it can no longer deliver its message. Human beings rather than God animate it, propelling it by a vision of the world measured by "progress" rather than humanity. When wondering as to the nature of the angel's message in Benjamin, Geoffrey Hartman describes Klee's image as having "thick candelabra fingers and heady excrescences, curlers that it is tempting to see as unfolding scrolls, possibly Torah scrolls?" If the wings have been disabled, perhaps there is still hope of retrieving the angelic legacy in the head of unfolding scrolls.

Unfold, unfurl. Diamond's case: to characterize Jewish theology as *unbound* (his italics) rather than doctrinal and systematic: angelic, Klee-esque.

*

Postscript: A Klee painting from 1940, the year of both his and Benjamin's death (on June 29 and September 26, respectively), titled *Todesengel*, or *Angel of Death*, is very little known; I know of no books that have used it on their covers.

Angelus Novus, 1920
The Israel Museum, Jerusalem

James A. Diamond
Jewish Theology Unbound
Oxford University Press, 2018

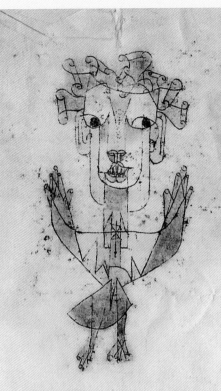

DIDIER FASSIN

LIFE

A CRITICAL USER'S MANUAL

This is the most recent book I know of featuring Benjamin's angel of death/life on its cover (encountered quite randomly in a Chicago bookstore). It evidently has the most ambitious title – an emphatic nod to Georges Perec's postmodern classic *Life: A User's Manual* from 1978. In a brief introductory note explaining his choice of the image on the cover, Fassin, a professor at the Institute for Advanced Study in Princeton, notes how Perec inaugurates his preamble to *La Vie mode d'emploi* with a Klee quote: "The eye follows the paths that have been laid down for it in the work."

The minutiae of Benjamin's angelology, and the minuteness of *all* Klee, encapsulate, respectively (to paraphrase the chapters of Fassin's unassuming book), a form of life, an ethics of life, and a politics of life: "hence the minimalist title; hence the shift of focus to the singularity of the individual; hence the affirmation of the relevance of philosophy as defense of life – whether true, right, or good." Philosophy today turns to Klee in search of the consolation of insignificance – of the power of the small.

Angelus Novus, 1920
The Israel Museum, Jerusalem

Didier Fassin
Life: A Critical User's Manual
Polity, 2018

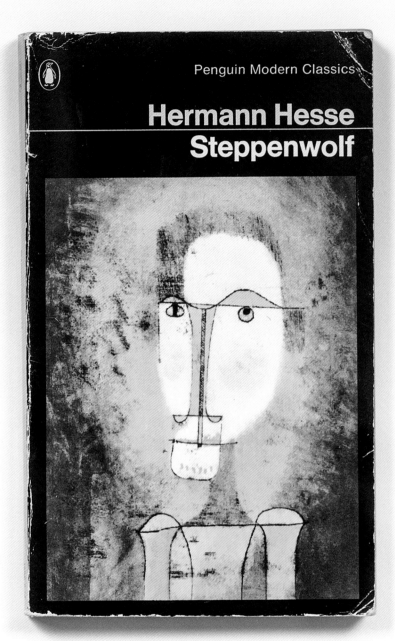

Hermann Hesse
Steppenwolf

This is one of two Hermann Hesse novels published by Penguin Books in the early 1970s that was entrusted with a Paul Klee cover. Hesse and Klee were born less than two years apart (the former in 1877, the latter in 1879), in Southwestern Germany and Central Switzerland, respectively – Hesse a German who became a Swiss writer, Klee a Swiss who became a German artist. Klee wrote poems (which were only published after his death), while Hesse painted watercolor landscapes. Yet somewhat improbably, they never met – the closest they came to crossing paths was in Hesse's 1932 novella *Die Morgenlandfahrt* (translated as "Journey to the East"), where Klee makes an appearance as a fictional character alongside Plato, Don Quixote, Mozart, Baudelaire, and a certain Klingsor – the Expressionist painter-character at the center of Hesse's 1920 novel, *Klingsor's Last Summer.* This motley crew is called "The League," a branch of which breaks off to seek and find the ultimate truth in the book's titular East.

According to the art historian Sabine Rewald, this picture – painted at a time when Klee was starting to develop his theory of the active line for his first Bauhaus courses – "is not the portrait of a man from China, as the title suggests, but of a man with yellow hair, a yellow suit, and as glum a mien as one might encounter in the portraits of stern ancestors. Brow, upper lip, and shoulder line are indicated by four horizontal and two vertical lines. Sinuous lines around these form the eyebrows, the nostrils, the chin, and a pair of padded shoulders. A tuft of yellow hair hangs down above the right, catlike eye into a long face with rouged and contourless cheeks. In the sense of the word, Klee playfully drew here what in German is called a Männeken Strich (a little man made out of lines)."

Harry Haller, as the Steppenwolf is known by his birthname in Hesse's eponymous 1927 novel, is nowhere described as having a yellow complexion or hailing from China – though there is perhaps something of the stick figure about him. As even his creator put it, "Altogether he gave the impression of having come out of an alien world, from another continent perhaps."

Bildnis eines Gelben

(Portrait of a Yellow Man), 1920

Metropolitan Museum of Art, New York

Hermann Hesse

Steppenwolf

Penguin, 1973

Aesthetics

and

Modern Jewish Thought

The Shape *of* Revelation

ZACHARY BRAITERMAN

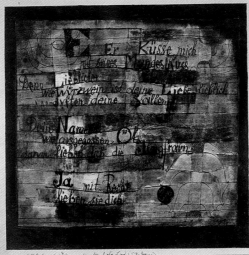

✳ STANFORD STUDIES IN JEWISH HISTORY AND CULTURE ✳

The Shape of Revelation: Aesthetics and Modern Jewish Thought "explores the overlap between revelation and aesthetic form from the perspective of Judaism. It does so by setting the Jewish philosophy of Martin Buber and Franz Rosenzweig alongside its immediate visual environment in the aesthetics of early German modernism, most notably alongside 'the spiritual in art' as it appears in the art and art theories of Vassily Kandinsky, Paul Klee, and Franz Marc." Klee is omnipresent; a work from 1919, *Villa R*, prefaces Braiterman's panoramic preamble. "Without overt religious reference" – Klee was not an overtly religious man; he was labeled a Jew to hasten the marginalization of his work in the *Entartete Kunst* era even though he was not Jewish – "*Villa R* reveals no God, no new angel with which to plumb the relationship between religion and art. In Klee's work, the affinity between the one and the other is formal and coy. Nature is no longer natural. Objects are no longer three-dimensional." At once worldly and otherworldly – the very image of modern doubt in the eye of the storm of secularization.

Er Küsse mich mit seines Mundes Kuss (Let Him Kiss Me with the Kisses of His Mouth), the work from 1921 reproduced on the cover of Braiterman's study, draws its title from Solomon's Song of Songs. Klee's version, phrased with the help of his father, Hans, with whom Paul shared an interest in Mesopotamian antiquity, continues: "for your love is more delightful than wine. Pleasing is the fragrance of your perfumes; your name is like perfume poured out. No wonder the young women love you." It is tempting to discern a certain technical strand of Jewish thought in Klee's calligraphic rendering of words as images – the mystique of naming and saying, incantation and invocation; the prohibition on "graven images" – though the more direct inspiration may have been the erotic tenor of Solomon's fabled scroll: Klee made this work at a time of expansive theoretical engagement with the masculine/feminine dialectic of art-making. In a chapter dedicated to a certain erotic current coursing through early twentieth-century Jewish thought, Braiterman notes how "referring to the act of artistic creativity as a 'genesis,' Klee wrote from Tunisia, 'In the beginning the motif, insertion of energy, sperm.' Form 'in the material sense' constitutes the artwork's 'primitive female component' against which 'form-determining sperm' constitutes a male counterpart. His own drawings belong to the male realm." The shape of revelation, in other words, remains firmly wedded to patriarchy.

Er Küsse mich mit seines Mundes Kuss

(Let Him Kiss Me with the Kisses of His Mouth), 1921

Solomon R. Guggenheim Museum, New York

Zachary Braiterman

The Shape of Revelation

Stanford University Press, 2007

The
Twitter Machine

Reflections on Language

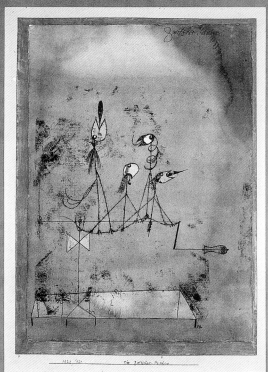

NEIL SMITH

Twittering Machine (1922) is the kind of Klee drawing that you'd expect to see appear on more book covers than the single instance I have been able to track down. Curiously, it has hardly featured (as far as I know, and I don't know much) in any visualization of the social media phenomenon that is Twitter – though that's probably a good thing. Made while Klee was a professor at the Bauhaus in Dessau, *Twittering Machine* was one of the more high-profile victims of the "Degenerate Art" purge initiated by the Nazis after Hitler rose to power in 1933. It was acquired by the Museum of Modern Art in New York in the late 1930s and came to symbolize Klee's ever-growing popularity among American postwar artists keen on renegotiating the politicized balance between abstraction and figuration. According to a Kay Larson feature published in *New York* magazine in 1987, *Twittering Machine* is also an especially popular children's-bedroom fixture.

Not surprisingly, given the inherent musicality of the score-like drawing of birds on a wire – Klee's father was a music teacher, his mother a singer – *Twittering Machine* has inspired its fair share of musical interpretations, the best known of which is perhaps Gunther Schuller's *Seven Studies on Themes of Paul Klee*. (On a related note: a reproduction of *Twittering Machine* introduces the chapter "1837: Of the Refrain" in Gilles Deleuze and Félix Guattari's landmark *A Thousand Plateaus*.)

Neil Smith's prophetically titled *The Twitter Machine: Reflections on Language*, published in 1989 (the Twitter we all know was launched in 2006) as a primer on modern linguistic theory, opens with an Italo Calvino quote that reveals the endeavor's debt to high postmodernism: "But what if language were really the goal towards which everything in existence tends?" Indeed, in a chapter titled "Data, Evidence, and Theory Change," Smith opines: "According to Mr Gradgrind [this is a reference to the protagonist of Charles Dickens's *Hard Times*, a character associated with the inclination to extol facts and numbers above all else], 'facts alone are wanted in life,' and there is a common belief that the heart of science involves amassing a large collection of facts and accounting for them by postulating general laws. If, however, one is asked, 'What is a fact?' the answer will depend to a large extent not only on the domain of interest but one's theory about that domain." Rereading the very question "What is a fact?" today evidently sends a mild shiver down our collective spine, beleaguered as we are by the centrifugal forces of social media divined in Klee's delicate drawing. In fact, taking another look at the birds in *Twittering Machine* with this very experience in mind, we can now focus on the crank driving the perch on which Klee's creatures rest: They are wind-up birds, spouting "language" on demiurgic demand.

Die Zwitscher-Maschine
(Twittering Machine), 1922
MoMA, New York

Neil Smith
The Twitter Machine
Wiley-Blackwell, 1989

DERRIDA:
A Critical Reader

Edited by
David Wood

Looking at the cover of this book, one is inevitably tempted to think, out loud, "Why don't we see more Paul Klee works on Jacques Derrida book covers?" Truly, they seem made for each other. Can one think of anything better to put on the cover of *Dissemination, Of Grammatology*, and *Writing and Difference* – the very title! – than a Klee drawing? Derrida was, of course, well aware of the semantic riches of Klee's work, and therefore mindful, perhaps, of facile exploitation: Just one Klee painting from 1927, *Constructiv-impressiv*, is deemed worthy of mention in his contentious 1979 opus, *The Truth in Painting*, and that's about it. As Stephen H. Watson notes in his study *Crescent Moon over the Rational: Philosophical Interpretations of Paul Klee*, "For Derrida the graphic line that was originally the basis of Klee's art, far from being the site of a cosmological origin" – a subtle rebuke of Heidegger's occasional philosophical overestimation of Klee's doodles – "was the inauguration of a transcendental withdrawal; it marked the trace of an invisible that will never become visible, the site of a certain 'blindness' all drawing ever repeats." The trace of an invisible that will never become visible: an arch-Derridean formulation – though how can a certain trace be ascribed to the invisible, i.e. to an element of the world of vision, if we know *beforehand* that it will never become visible, i.e. enter into the world of vision? (I love the title of Watson's book; the Klee drawing on the cover depicts a crescent moon indeed – first quarter: an intimation of the spread of reason, we may surmise.)

Analysis of Diverse Perversities is a drawing made in 1922; it resembles the contemporaneous *Twittering Machine* in its enthusiasm for schematization, mechanics, and machinery (did Klee ever cross paths with Francis Picabia at the height of his Dada notoriety?): Arrows, levers, springs, and vectors connect the mad scientist in the bottom right with a caged bird in the top left in a scene mildly reminiscent of Joseph Wright of Derby's macabre *Experiment on a Bird in the Air Pump* from 1768. ("You want science? Here you have it!") ("Perversities," by the way, is an interesting word in Klee's generally abstemious universe.)

Here's a possible description of Klee's analyst, lifted from Derrida's essay "Passions: An Oblique Offering": "Let us imagine a scholar. A specialist in ritual analysis, he seizes upon this work, assuming that someone has not presented with it (something we will never know). At any rate, he makes quite a thing of it, believing he can recognize in it the ritualized unfolding of a ceremony, or even a liturgy, and this becomes a theme, an *object* of analysis for him. Ritual, to be sure, does not define a field. There is ritual everywhere. Without it, there would be no society, no institutions, no history." There are only diverse perversities.

Analyse verschiedener Perversitäten

(Analysis of Diverse Perversities), 1922

Centre Georges Pompidou, Paris

David Wood (ed.)

Derrida: A Critical Reader

Wiley-Blackwell, 1992

ROBERT C. SOLOMON

TRUE TO OUR FEELINGS

WHAT OUR EMOTIONS ARE REALLY TELLING US

This painting, also known under the title *Head of a Man Going Senile*, shows Klee at his most whimsical and humorous. Made in the same year as his *Twittering Machine*, it reveals something of Klee's spiritual debt to the gentle, ludic anarchism of Zurich Dada (as opposed to its more caustic, politicized Berlin counterpart). Though there are obvious echoes of African mask art, cubism, and suprematism to be discerned in this crude portrait of a "tiny old man," the more revealing point of comparison might be that of the vibrant satirical tradition flourishing in Germany at the time – think, for instance, of George Grosz's scathing caricatures of the pillars of Weimar society. The year 1922 was particularly productive for Klee, but also a very momentous one in Germany's immediate postwar period, witnessing the assassination of Walther Rathenau and the dizzying depreciation of the mark, which would pave the way for a proliferation of extremist political discourse culminating in Adolf Hitler's Beer Hall Putsch of 1923. (Is that a tiny, neatly trimmed moustache we're seeing, or are those just Senecio's nostrils?)

Klee's *petit vieillard* does seem a little disgruntled, perturbed – the familiar face of aggravation. The first chapter of Robert C. Solomon's *True to Our Feelings: What Our Emotions Are Really Telling Us* is titled "Anger as a Way of Engaging the World." In it, Solomon argues that "anger is basically a judgment that one has been wronged or offended" as well as a "famously judgmental emotion." It was Solomon's last book, published in the year of his untimely death, 2007. He was spared, in other words, a wholly new understanding of the word in our current age of anger.

Senecio (petit vieillard)
(A Tiny Old Man), 1922
Kunstmuseum Basel

Robert C. Solomon
True to Our Feelings
Oxford University Press, 2007

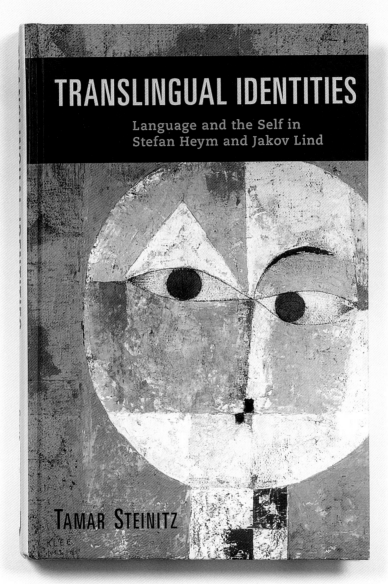

TRANSLINGUAL IDENTITIES

Language and the Self in
Stefan Heym and Jakov Lind

TAMAR STEINITZ

This book is devoted to the work of two relatively little-known authors born into the German-language sphere who published primarily or exclusively in the English language of their adopted homes and postwar ("translingual") identities. Both were born into assimilated Jewish milieus: Stefan Heym as Helmut Flieg in Chemnitz, Germany, in 1913, and Jakov Lind as Heinz Landwirth in Vienna, Austria, in 1927. Both led adventurous, restless lives, shaped in the main by the Nazi experience of the 1930s and 1940s. Having started on a path of politically engaged journalism, Heym fled to Prague in 1933, moving on to the USA in 1935 to study at the University of Chicago. He spent the war years and their immediate aftermath in America, eventually fleeing the oppressive conservative climate of the McCarthy era for a new life in the newly founded German Democratic Republic. The disappointments of the Ulbricht and Honecker regimes notwithstanding, he remained a steadfast apologist of the socialist gospel, critical of the stark asymmetries of the German reunification after the GDR's demise in 1991. Ever the wandering Jew, Heym died aged 88 in December 2001 while visiting Israel on the occasion of a Heinrich Heine conference. With some effort, one can discern his deep-grooved old-man features in Klee's portrait. Lind's family narrowly escaped arrest and deportation in the early days of the Anschluss in 1938, after which he was sent on a Kindertransport to the Netherlands. Assuming the identity of a Dutch laborer named Jan Gerrit Overbeek, Lind improbably survived the war working on a barge carrying coal into Germany. Towards the war's end he once again changed identities to overcome immigration restrictions, reinventing himself as a Palestinian-born Jew called Jacov Chaklan on his way to Haifa. In 1950 he moved back to his native Vienna, then Amsterdam again, and finally London, where he settled in 1954 to become a writer. He died in his English home in February 2007. Heym actually wrote a book titled *The Wandering Jew* – the 1984 translation into English (by the author himself) of his 1981 German-language book titled *Ahasver*. (A 2005 edition of Heym's mid-1960s novel *The Architects* has Klee's *Revolution des Viadukts*, from 1937, on its cover.) Lind's 1987 epistolary novel *The Inventor* likewise contains many wandering Jews musing on the plight of exile and the virtues and blessings of existential homelessness: The language *of their choice* was these writers' only roof above their head.

Klee's tiny old man does not appear to have a mouth now, does he? No language for him, born of the linguistic tumult of 1920s Central Europe. (Klee painted this picture in the same year James Joyce's *Ulysses* – the ultimate tale of the Wandering Jew as loquacious everyman – was first published in a tiny print run in Paris.)

Senecio (petit vieillard)
(A Tiny Old Man), 1922
Kunstmuseum Basel

Tamar Steinitz
Translingual Identities
Boydell & Brewer, 2013

DANIEL C. DENNETT

Author of CONSCIOUSNESS EXPLAINED

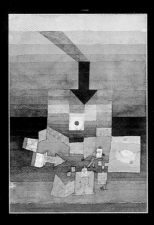

INTUITION PUMPS *and* OTHER TOOLS *for* THINKING

Daniel C. Dennett clearly *loves* Paul Klee: Four of his books – and his best known, most widely read among them – sport Paul Klee paintings on their covers. It seems fair to assume that these have been authorial choices as much as editorial ones: In the most recent of these books, *Intuition Pumps and Other Tools for Thinking*, Dennett actually references Klee as one of the presumed authors of the phrase "to make the familiar strange," which he calls one of the "self-appointed tasks" that both artists and philosophers agree to share: "among those credited with the aphorism are the philosopher Ludwig Wittgenstein, the artist Paul Klee, and the critic Viktor Shklovsky." Klee appears in this fashion in a brief chapter titled "Folk Psychology," in turn registered under the rubric of "tools for thinking about meaning or content"; "folk psychology" is roughly understood here as that which the artist (*and* the philosopher) seeks to destabilize, undermine – smite with the sword of *defamiliarization*.

Betroffener Ort was painted in 1922, during Klee's tenure at the Bauhaus in Dessau, where he was quick to befriend the newly arrived Russian "inventor" of abstract art, Vassily Kandinsky. The painting's titular "affected place" may refer to the jumble of fence-like curlicues in the center of the image – a deserted village square or garden? a patch of interiority? – impacted by a bold, fairly menacing arrow thundering its way down the horizon like a lightning bolt or the sword of Damocles. Klee himself understood this impact in geological terms, calling the play of horizontals and verticals a *fault*: "the arrow's target is the center of the earth" – the citadel of certainty, perhaps, of the preconceived notions that constitute the life of the mind as we know it. *Betroffener Ort* certainly ranks among Klee's more "aggressive" works; the contrarian charge of its angular energy resembles the true hardness of thought.

Something of that systemic, static violence (geological rather than biological, let alone ideological) certainly resonates in the framework of concerns that pervade Wendy Brown's *States of Injury: Power and Freedom in Late Modernity* – a better use, perhaps, of Klee's *Betroffener Ort*: One of Brown's primary theoretical preoccupations concerns the "liberal, capitalist, and disciplinary origins of the force of *ressentiment* in late modern and political discourse." (*States of Injury* was published in 1995, long before the depths plumbed by our current culture of resentment.) Brown's other principal interest is in the tangle of freedom and identity, a relationship that "yields the paradox in which the first imaginings of freedom are always constrained by and potentially even require the very structure of oppression that freedom emerges to oppose." Echoes of this selfsame paradox resound in Klee's political experience of the 1910s and 1920s. In 1920, after two decades of a freelancer's vacillating revolutionary romanticism, he was appointed professor at a state institution that itself had moved on from its origins in the revolutionary utopianism of the Arbeitsräte to the administrative reason of social practicality. Works like *Betroffener Ort* signal a gradual turning away from political posturing; the "affected place" may well be Klee's slightly disillusioned, armchair-anarchist self.

Betroffener Ort
(Affected Place), 1922
Zentrum Paul Klee, Bern

Daniel C. Dennett
Intuition Pumps and Other Tools for Thinking
W. W. Norton, 2013

STATES
OF
INJURY

POWER AND FREEDOM IN LATE MODERNITY

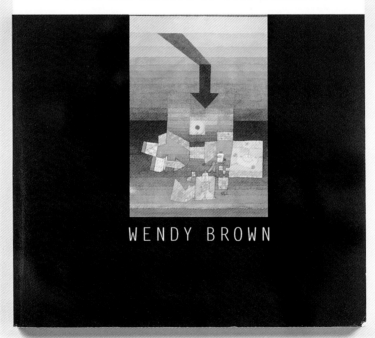

WENDY BROWN

Betroffener Ort
(Affected Place), 1922
Zentrum Paul Klee, Bern

Wendy Brown
States of Injury
Princeton University Press, 1995

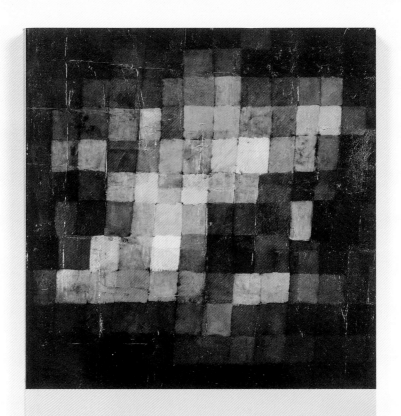

JUDAISM MUSICAL
AND UNMUSICAL

Michael P. Steinberg

The purported "Jewishness" and musicality of Klee's work converge in the title of this book by the historian and musicologist Michael P. Steinberg, the cover of which depicts a painting from Klee's Bauhaus years. Its title is translated as "Ancient Harmony," though the original German, *Alte Klang*, is more accurately rendered as "Ancient Sound" – surely not all sound is necessarily harmonious? The work is part of a series dating to the mid-1920s that represents Klee's most sustained engagement with abstract geometry, invoking notions of polyphony and rhythm as well as architecture and the organization of space.

Already in the 1910s, Klee had remarked: "One day I must be able to improvise freely on the keyboard of colors: the row of watercolors in my paint box." His musical taste, however, remained thoroughly conventional, conservative even: Bach and Mozart, as opposed to the jagged modernism of composers like Hauer, Hindemith, Schoenberg, or Stefan Wolpe – a student at the Bauhaus during Klee's tenure there – whom we are perhaps more likely to hear when looking at, and listening to, paintings such as *Alte Klang*.

Why does musicality matter to Steinberg in a book that is ostensibly a study of modernity and Jewish self-consciousness? (The title is partly a riff on Max Weber's quip, "*Ich bin religiös unmusikalisch*": I am unmusical in matters that regard religion.) "To be musical, to recognize the aesthetic and cultural importance of music, is to recognize the presence of meaning in a non-signifying practice," Steinberg writes. And why does he think, in conclusion, that *Jews and music are the same*? "At stake in the cases of both music and Jews are non-essentializable products of history, temporally, culturally, politically contingent beings, whose own subjectivities and subject-positions are aesthetically constituted and therefore require an aesthetic dimension from the discourses that attempt to understand them." Giving a trace of infinity to the temporal, as in Klee's subtly shape-shifting grids.

Alte Klang also makes an appearance on the record cover of Takashi Kako's 1988 Third Stream–tinged jazz suite *Klee*.

Alte Klang

(Ancient Harmony), 1925

Kunstmuseum Basel

Michael P. Steinberg

Judaism Musical and Unmusical

University of Chicago Press, 2007

The Handbook of
CRITICAL
THEORY

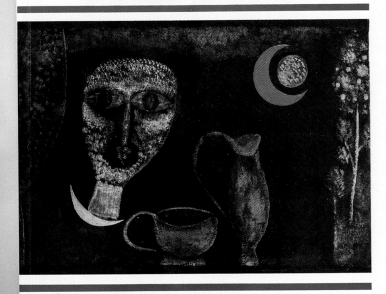

Edited by
DAVID M. RASMUSSEN

For a more sustained consideration of the association of Klee's imagery with the history of Critical Theory and the original Frankfurt School in particular, see the entry on *Hauptweg und Nebenwege* (1929) on the cover of David Held's *Introduction to Critical Theory* (1980) – the former far and away a better visual fit in any case.

A couple of words are in order on *Keramisch-mystisch*, however, the only Klee painting in this series of book covers to reside in a private collection, and something of an anomaly in its literal figuration (i.e., easily recognized cup and pitcher, face, sun, and moon). This painting dates back to 1925, the early years of the Weimar era, during which time Klee taught at the Dessau Bauhaus, where he would have been exposed to ceramic arts and pottery – though the Bauhaus pottery workshop, located in the small Thuringian town of Dornburg, closed its doors in 1925. These were also the years that witnessed the founding – in 1923, to be more precise – of the Institute for Social Research in Frankfurt, the spiritual home of Critical Theory as a historical force in twentieth-century philosophy. Ceramics certainly enjoyed a modernizing revival in 1920s Germany, though its association with traditions of artisanship inevitably meant it only accrued limited significance in the Frankfurt School's extensive orbit of aesthetic reflections. The likes of Adorno, Benjamin, Horkheimer, Löwenthal, Pollock, and others preferred thinking about film, photography, related emergent forms of mass culture and the atonal vanguard of contemporary music; the era's most influential ceramically inspired thinking unfolded on the other side of Weimar's ideological divide, for instance in Heidegger's "The Origin of the Work of Art," fatefully published in the same year (1936) as its symbolic antonym, Benjamin's "The Work of Art in the Age of Mechanical Reproduction." *Keramisch-mystisch*, in other words, would have better suited a handbook of Heidegger studies or Heideggerian aesthetics – especially given its title, considering the Frankfurt School's deep suspicion of all that is traditionally named mystical.

In the German-language publishing sphere that lies outside the purview of our research, I have seen *Keramisch-mystisch* appear on the cover of a book titled *Psychodynamische Psychotherapie mit Älteren: Eine Einführung* ("Psychodynamic Psychotherapy with the Elderly: An Introduction"). The painting also adorns a CD recording of nocturnal piano music (Beethoven, Chopin, Schumann) by Stephen Hough, whose catalogue on the British Hyperion label distinguishes itself by a generous use of Klee imagery.

Keramisch-mystisch

(Ceramic Mystic), 1925

Private collection

David M. Rasmussen (ed.)

The Handbook of Critical Theory

Wiley-Blackwell, 1996

Janae Sholtz

THE
INVENTION
OF A PEOPLE

HEIDEGGER AND DELEUZE
ON ART AND THE POLITICAL

Something of an oddity, this book cover with Klee's *Magic Garden* on it – a work, one might say, that does not reproduce well. Painted in 1926, the work was executed on a plaster-filled wire mesh frame, the imagery scratched rather than drawn, carved rather than painted – a challenge to the illusory flatness of the picture plane. There are echoes here of certain strands in Surrealist iconography (Chagall, Miro), as well as premonitions of the abrasions and grain of postwar *informel* (Fautrier, Wols), while the imagery itself harkens back to older, slightly more bourgeois artistic concerns – that of the garden (Monet's in particular) and horticulture as well as Edenic and Orientalist fantasies. There is, however, little very garden-like about Klee's picture – the painting's true content appears more cosmological in intent, with the blue sun to the right of the transfixed figure in the center commanding our attention above all else.

For Janae Sholtz, Klee's *Magic Garden* "exemplifies the cosmogenetic tendencies of his work. It discloses the dynamic emergence from chaotic immanence, resembling a 'primordial substance worn and textured by its own history. A cosmic eruption seems to have spewed forth forms... Although excused from the laws of gravity, each of these forms occupies a designated place in a new universe.' Certainly, one can identify human artefacts, goblets, architecture, but these are not privileged, centred beings; the force of genesis itself is the overarching construct, as it is as much the case that things recede into the maelstrom of the chaotic sensible." Sholtz's reading leans heavily on Heidegger and his well-documented love of Klee's work, which in his mind best captured the existential drama of the so-called *Riss* – the "rift" between earth and world in which creation as such becomes possible. Chasms, scratches, and tears abound in much of Klee's work: marks of the miracle of making that are especially alluring to a philosopher turning away from being towards becoming. (This is where Gilles Deleuze joins the conversation.)

Sholtz's study of art and politics in the Heideggerian-Deleuzian continuum departs from, and ultimately returns to, the specter of the "people," or Heideggerian *Volk*, as the deepest destiny of being as a being-with, a *mitdasein*; mindful of the catastrophic meaning this being-with acquired in Heidegger's wartime political sympathies, she concurs with Deleuze that "a people is, and must always be, to come": something "in the works." Teased out, and hinted at, in Klee's *Magic Garden*, perhaps, a picture of expectation, an image of waiting, a readying oneself – for a properly "inoperative community"?

Le jardin magique

(The Magic Garden), 1926

Solomon R. Guggenheim Museum, New York

Janae Sholtz

The Invention of a People

Edinburgh University Publishing, 2015

WHAT COMPUTERS STILL CAN'T DO

A Critique of Artificial Reason

HUBERT L. DREYFUS

Well-matched: a Klee drawing titled *The Limits of Intelligence* on the cover of a book titled *What Computers Still Can't Do*. (The German word "*Verstand*" can also be translated as "mind" or "sense," understanding or reason.)

Klee's drawing dates back to his final years at the Bauhaus in Dessau, a bulwark of functionalist aesthetics that, towards the end of its short-lived existence in Weimar Germany, became increasingly enamored with the rationalist mirage of a fully mechanized, machinic life. The drawing consists of an elaborate meshwork of finely drawn lines in its bottom half – reminiscent of the work of Naum Gabo or László Moholy-Nagy – that crystallize in a sequence of tiny ladders, precariously balanced yet leading ever upward, towards a red globe lighting up the drawing's upper half, casting a shadow right underneath. (Moholy-Nagy had been one of the newer Bauhaus hires who had helped weed out the vestigial Expressionism of the school's wartime roots – a shift that contributed to Klee's growing frustration with the Bauhaus's narrowing intellectual scope.) The lower part of the picture may be interpreted as the field of reason's inner workings – the weaving of thought, sense, mind, trying to snake its way upward, yet inevitably crashing into the "limits of intelligence" when groping for the dark-red sun of transcendence. Perhaps.

The first edition of Dreyfus's classic philosophical account of the challenges of artificial intelligence (the book was published in 1972) came Klee-less, sporting a picture of a plug pulling out of a socket on its cover instead. Dreyfus's claim that disembodied machines were (are?) inherently unable to mimic the higher functions of the human mind were met with uproar and ridicule in the artificial intelligence community at the time, though when the third edition was published in 1993, he felt sufficiently vindicated to reiterate in the preface: "Now that the twentieth century is drawing to a close, it is becoming clear that one of the great dreams of the century is ending too. Almost half a century ago computer pioneer Alan Turing suggested that a high-speed digital computer, programmed with rules and facts, might exhibit intelligent behavior. Thus was born the field later called artificial intelligence (AI). After fifty years of effort, however, it is now clear to all but a few diehards that this attempt to produce general intelligence has failed." This is primarily so, it should be noted here, because "the research program based on the assumption that human beings produce intelligence using facts and rules has reached a dead end, and there is no reason to think it could ever succeed." Human caprice, it seems (or is implied), draws the ultimate "*Grenze des Verstandes*" – the red sun scorching all and sundry in Klee's micro/multiverse.

Grenzen des Verstandes

(The Limits of Intelligence), 1927

Pinakothek der Moderne, Munich

Hubert L. Dreyfus

What Computers Still Can't Do

The MIT Press, 1993

Penguin Modern Classics

Hermann Hesse
The Glass Bead Game

As mentioned earlier, this is the one Paul Klee painting Jacques Derrida references in his treatise on aesthetics *The Truth in Painting*: a book that appears to be "about" painting, but that is really much more "around" painting; a book about frames rather than the pictures framed within (*La vérité en peinture* was published in 1979, the highwater mark of postmodernism); a book about the institutions that produce the experience of painting as we know it – all the way from the studio and the museum to the nails, presumably, from which a painting can on occasion be seen to be hanging. Derrida: "When nails are painted (as they are by Klee in his *Constructif-impressionant* of 1927), as figure on a ground, what is their place? To what system do they belong?" I am not so sure whether I really *see* Derrida's nails in Klee's painting on the cover of Hesse's book, the author's last – begun in 1931 but completed in exile and published in Switzerland in 1943.

The book has also been published under the Latin title *Magister Ludi*, "master of the game." About which Hesse noted the following: "These rules, the sign language and grammar of the Game, constitute a kind of highly developed secret language drawing upon several sciences and arts, but especially mathematics and music (and/or musicology), and capable of expressing and establishing interrelationships between the content and conclusions of nearly all scholarly disciplines. The Glass Bead Game is thus a mode of playing with the total contents and values of our culture; it plays with them as, say, in the great age of the arts a painter might have played with the colours on his palette."

Constructiv-impressiv

(Constructive-Impressive), 1927

Kunstmuseum Bern

Hermann Hesse

The Glass Bead Game

Penguin, 1974

GIOVANNI ARRIGHI

THE LONG
TWENTIETH
CENTURY

The late Giovanni Arrighi may have been something of a Klee aficionado. The image on the cover of his magnum opus, *The Long Twentieth Century: Money, Power, and the Origins of Our Times*, is credited as a Klee painting from 1928 titled *Plummets to the Wave* – about which I have been unable to find more information. The painting appears to depict a sun-like celestial body hovering over a stormy sea, its rays of light crashing into the undulating waves below – a reflection, perhaps (if the painting is correctly dated – compare with the much more tranquil imagery of the mid-1920s), of the turbulent moment of worldwide economic upheaval Klee was living through at the time of its completion: We are just one year away from the most momentous crisis in twentieth-century history.

Waves, ripples, and crashes feature prominently in Arrighi's analysis (first published in 1994, at the height of post–Cold War confidence in the global liberal consensus) of the epochal shifts between capital accumulation and state formation over a 700-year period, the famed Kondratiev cycle being the best-known wave-like model for the theorization of boom and bust. Nikolai Kondratiev published his landmark *The Major Economic Cycles* in 1925, towards the end of the New Economic Policy he had become so closely associated with. Stalin aborted the NEP experiment in 1928, the year Klee painted the aforementioned work. Ten years later, at the height of the purges, Kondratiev was executed by firing squad. His work was only rediscovered in the 1970s by *longue durée* historians and Marxist economists like Fernand Braudel, Ernest Mandel, and Immanuel Wallerstein. Arrighi's theory of "systemic cycles," hashed out in a constant dialogue with the work of Braudel and Wallerstein, signals a departure from Kondratiev waves: Whereas the latter are typically assumed to encompass a 45- to 60-year span – it should be noted here that most academic economists contest the existence of such cycles – Arrighi's "long century" denotes "an age during which a hegemonic power deploying a novel combination of economic and political networks secured control over an expanding world-economic space."

The febrile political excitement of late 1920s Bauhaus – in 1928, the radical functionalist Hannes Meyer became director, shifting the school's politics even more to the left – proved too volatile for Klee's artistic temperament. After he moved to Düsseldorf in 1930 to assume a professorship at the art academy there, his work would gradually move away from the jagged, muscular language of crashes and crises, precipitous drops and radical upheavals.

Lote zur Welle
(Plummets to the Wave), 1928
Location unknown

Giovanni Arrighi
The Long Twentieth Century
Verso, 1994

THE PRODUCTION OF
SPACE

— *Henri Lefebvre* —

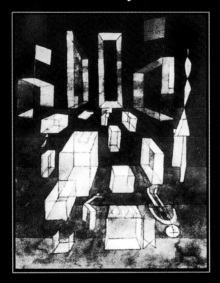

TRANSLATED BY
DONALD NICHOLSON~SMITH

Uncomposed in Space (1929) is an aquarelle that is much more colorful than its repro-duction on this cover of Henri Lefebvre's *The Production of Space* (originally published in 1974) manages to suggest. Lefebvre's classic text opens by stating that "not so many years ago, the word 'space' had a strictly geometrical meaning: the idea it evoked was simply that of an empty area…. To speak of 'social space' would have sounded strange." The French Marxist philosopher goes on to credit the artists of the Bauhaus, and Paul Klee in particular, with both creating and fostering a new awareness of space: "for the Bauhaus did more than locate space in its real context or supply a new perspective on it: it developed a new conception, a global concept, of space…. As Paul Klee put it, artists – painters, sculptors or architects – do not show space, they create it" – a remark he himself equates with a much-quoted earlier saying of Klee that "art does not reflect the visible, it renders visible."

Klee's enigmatic watercolor reads like a comment on the stasis of Euclidean perspective: A dozen geometric forms, mostly rectangular, appear frozen in an outward, dispersing movement. The only form that confronts us head on, in two stark dimensions, is colored a deep, morbid black – a suprematist echo of the negativity of all transcendence. More importantly, Klee's picture also features a figure, shown floored in the bottom right corner, as if bulldozed by the relentless expansion of regimented, architectonic space. (1929, the year Klee made this work, was something of an *annus mirabilis* for visions of infinity: That year, Edwin Hubble published his theory of the ever-expanding universe, while Kurt Gödel introduced the world to his completeness theorem.) The history of the Bauhaus with which Klee is so closely associated is deeply entwined, of course, with the push towards the unending rationalization of living and working space – the space it pro-duced, to paraphrase Lefebvre's title, was an eminently mechanical and, in the long run, inhuman one, rendering the human form invisible.

Nichtcomponiertes im Raum
(Uncomposed in Space), 1929
Neue Pinakothek, Munich

Henri Lefebvre
The Production of Space
Wiley-Blackwell, 1992

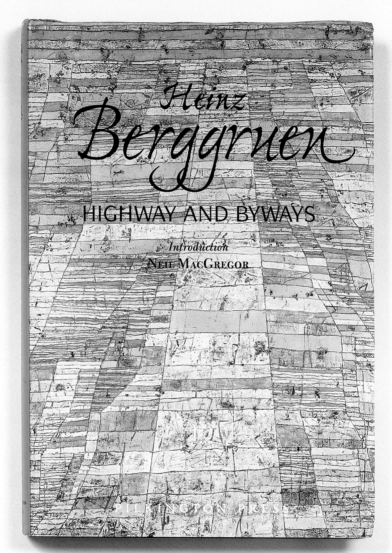

Heinz
Berggruen

HIGHWAY AND BYWAYS

Introduction
NEIL MACGREGOR

PILKINGTON PRESS

Highway and Byways (1929) was painted in Dessau six months after Klee's return from Egypt, a transformative journey much like an earlier trip to Tunisia. According to some interpreters, the painting's richly textured interplay of parallel horizontals – gently receding towards the horizon in the image's central path or "highway" – and converging verticals is meant to conjure the patchwork of grain fields on either side of the Nile River, hinted at in the narrow bands of blue in the distance. The image's faint pyramidal structure likewise invokes the land of the pharaohs, which, through the art of the hieroglyph, had so long transfixed the artist's imagination.

This is surely one of Klee's most eloquent and iconic works, freely inviting, through its infectious title, a plethora of interpretations. It is not surprising to see it grace the cover of the memoirs of Heinz Berggruen, the German-Jewish art dealer and collector whose name lives on in the Berggruen Museum in his native Berlin – a collection that started out in 1940 when he bought his first Paul Klee drawing for a neat hundred dollars from a fellow Jewish refugee to America during a stopover in Chicago. "Even as a young man I loved Klee," Berggruen reflected. "He was the first painter who occupied me intensely; he had a decisive influence on my career as a collector and dealer. I originally chose the title of one of Klee's paintings for my memoirs in homage to him, not only because of my reverence for Klee, but also because I saw *Highway and Byways* as a code, a condensed expression of everything I intended to relate in this book" – i.e., the story of life's countless inspiring detours occasionally merging with the straight and narrow. The Klee drawing acquired by Berggruen in 1940, *Phantom Perspective*, dated to Klee's early years at the Bauhaus, is now owned by the Metropolitan Museum of Art in New York. Berggruen continued: "*Phantom Perspective* became my constant companion, my protector and my talisman. Later, when I was looking at this magical painting, I often thought of Walter Benjamin, who took his beautiful Klee water-color *Angelus Novus* of 1920 around with him like a talisman from place to place." About Klee's universe in general, Berggruen – who never met the artist – remarked that it "is as far from abstract as he himself is from being an abstract painter.... It is a world of secrets, of phantasmagorias and dreams, a world that is magical yet never arbitrary, which differentiates without ever being obvious.... It is a world of silence and quietly ringing tones, of poetry and soft music. This secret and cozy world holds ever new discoveries and surprises for all those who enter it."

Berggruen never owned, or exhibited, *Highway and Byways*. It was shown alongside two other works of a similar "geological" inspiration in an exhibition of the German Artist Union in Cologne in the year of its creation, where it was acquired (after the crash?) by a local collector named Werner Vowinckel. The Vowinckel family sold the work to the Wallraf-Richatz Museum in Cologne in 1974; two years later it was transferred to the Museum Ludwig. An uncharacteristically straight story, perhaps, in the cultural moonscape of postwar Germany.

Hauptweg und Nebenwege

(Highway and Byways), 1929

Museum Ludwig, Cologne

Heinz Berggruen

Highway and Byways

Pilkington Press, 1999

Introduction to
Critical Theory
Horkheimer to Habermas

David Held

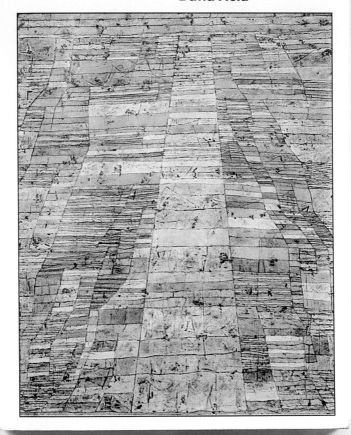

Is it just the Walter Benjamin/*Angelus Novus* connection that is at the root of the long association of Paul Klee with Critical Theory and the philosophy of the Frankfurt School? No: This intricately drawn work from the 1920s in particular seems custom-made to illuminate the ideas of Adorno, Horkheimer, Marcuse et al., much like the cruder, more primitivist work of the 1930s is so often a peerless match for the correspondingly "crude" and "primitivist" philosophy of Martin Heidegger. What better way to "illustrate" the notion of critique as theory than by way of an image depicting myriad byways (the Adornian tactic of diversion) crowding around a single mono-minded highway (the Heideggerian myth of a knowable origin)? *Hauptweg und Nebenwege* is perhaps the closest Klee ever came to capturing in paint the capricious, shimmering essence of dialectics, or the "dialectical imagination" at work (to paraphrase the title of Martin Jay's 1973 history of the Frankfurt School).

David Held's slightly later history of the Frankfurt School concludes with a last look at Homer's *Odyssey*, a touchstone of Adorno and Horkheimer's theorization of "instrumental reason" as recounted and related in their *Dialectic of Enlightenment*: "Homeland is, of course, the *telos* of the Homeric journey," Held writes. "Odysseus' return, anticipating the possible homecoming of Western human beings, is to a life 'wrested from myth.' His home, however, does not allow us to forget the horror of his journey. Nor do we forget that the home is *his*. The Odyssean homecoming might promise reconciliation between people and nature, and between people and one another, but it remains a promise – it awaits actualization." It flickers on the horizon, like the Nile in the midday heat, and many roads may lead to it – the less well traveled, the better.

Hauptweg und Nebenwege

(Highway and Byways), 1929

Museum Ludwig, Cologne

David Held

Introduction to Critical Theory

University of California Press, 1980

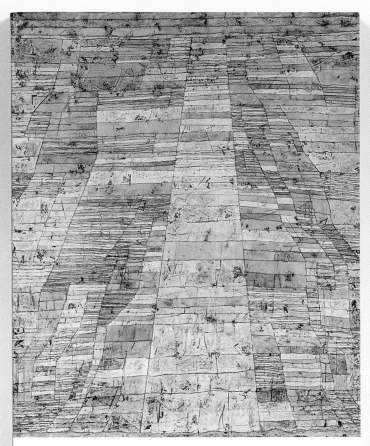

Why Choose
the Liberal Arts?

Mark William Roche

The art of the detour, of getting lost – the tao of diversion, footnotes, interjections – to digress and deviate, and see where the byways lead us.

In an age of increasing specialization and ever greater emphasis on immediately practical goals that has seen the number of students choosing the path of a liberal arts education dwindle dramatically – less than 5 percent of today's students are awarded an undergraduate degree in the liberal arts, down from a midcentury high of nearly 20 percent – Roche's book seeks to answer the need to articulate the diverse values of the liberal arts. This answer is already given in the book's cover image and the implied etymological twinning of the aforementioned *diversity* of values on the one hand and the value of *diversion* as such on the other hand. As Roche put it, "to educate, as in the Latin *educare*, means to lead out, to bring out from within" – the *Hauptweg*. To free (*liberare*) the mind to roam, freely, along *Nebenwege* instead. The journey is the thing, as Homer knew. ("Meander" is the name of a river in Asia Minor appearing, among other places, in the *Iliad*.)

Also, regarding previous uses of *Hauptweg und Nebenwege* – here is Roche again: "When the value of a liberal arts education is defended today, educators normally elevate not its intrinsic value, which is simply too foreign to contemporary culture, but critical thinking, which is essential to success and crucial to the venerable enlightenment goal of dismantling false truths." Did Klee sense something of the loss of such criticality in the Bauhaus's gradual narrowing of its own educational goals to an ever more instrumental rationality?

(*Hauptweg und Nebenwege* also appears on the cover of Richard Moran's *The Philosophical Imagination*, a collection of essays from 2017 not featured in this book. Nowhere in Moran's anthology does Paul Klee's name appear.)

Hauptweg und Nebenwege, incidentally, is another Klee work that has seen its fair share of musical interpretations, most notably in the Feldmanesque shape of a languidly meandering string quintet composed by Michael Denhoff. (Denhoff in the liner notes to the work's 2002 recording: "In late 1997 when I had the idea for a piece on which I would work for exactly one year – specifically, from January 1 to December 31 – a piece that would attempt to give form and shape in sound to the daily fluxes of thought, I spontaneously thought of Klee's painting.") "Incidentally," as it so happens, serendipitously. By the way.

Hauptweg und Nebenwege

(Highway and Byways), 1929

Museum Ludwig, Cologne

Mark William Roche

Why Choose the Liberal Arts?

University of Notre Dame Press, 2010

"István Mészáros illuminates the path ahead. He points to the central argument we must make in order…to take to the offensive throughout the world in moving toward socialism." —HUGO CHÁVEZ, President of Venezuela

The Structural Crisis of Capital

István Mészáros

FOREWORD BY JOHN BELLAMY FOSTER

This one is a bit of an outlier. Sure enough, as this very exercise attests, Paul Klee fares well with the Critical Theory, New Left, and faintly Western-Marxist crowd – but an out-and-out socialist screed by this former student of Georg Lukács? It is just a tiny bit jarring to read a Hugo Chávez blurb ("István Mészáros illuminates the path ahead. He points to the central argument we must make in order… to take the offensive throughout the world in moving toward socialism") atop one of Klee's more delicate, oh-so-musical mid-1930s abstractions (very poorly reproduced, one might add). Only a tiny bit jarring, mind you: We have already noted how Klee wholeheartedly and unequivocally supported the Communist cause of Munich's short-lived Soviet Republic – good for him.

Is this, then, how we should read a painting titled *Flowering* gracing the cover of a book dedicated to divining the "structural crisis of capital" and showing a way out of this crisis in the shape of a true socialist utopia? (In his introduction to this collection of essays, Richard Antunes observes quite astutely that "a phenomenology of crises has blossomed," accurately naming this particular crisis "an act of volition.") *Blühendes* strongly resembles a Klee work from 1925 titled *Abstrakt mit Bezug auf einen blühenden Baum*: abstraction with reference to a flowering tree. The painting from 1934 has shed this tree-like anchor in the real world of concretely lived experience and blossomed into a verb, pure and simple. "For only a radical *systemic change*" – the true work of *abstraction*, of piercing the veil of particulars – "can offer historically sustainable hope and a solution for the future." A flowering that *really* lurks around the corner, one must hope.

Blühendes

(Flowering), 1934

Kunstmuseum Winterthur

István Mészáros

The Structural Crisis of Capital

Monthly Review Press, 2010

ANTISYSTEMIC
M O V E M E N T S

GIOVANNI ARRIGHI,
TERENCE K. HOPKINS &
IMMANUEL WALLERSTEIN

I have not been able to identify the Paul Klee painting adorning the cover of *Antisystemic Movements*, an "eloquent and concise history of popular resistance and class struggle by the leading exponents of the 'world-systems' perspective on capitalism," Giovanni Arrighi, Terence K. Hopkins, and Immanuel Wallerstein. There are, after all, more than 10,000 works to choose from in Klee's immense *Nachlass*. It does beg the question, though – is it even allowed to put artwork on the cover of your book without so much as mentioning who it's by? In any case, my uninformed guess is that we are looking at late 1920s Klee here, leaving the angular era of forceful arrows behind (some), moving towards a slightly more biomorphic and melodic language of pictorial form: an artist tending, for the moment, towards harmonies and harmonization.

The Klee painting on the cover of *Antisystemic Movements* resembles something of a labyrinthine landscape seen (inevitably) from above – laborious inner workings turned geological, earth-like. Three small arrows at the far left point towards the contorted green mass in the middle; out of the spiraling, twisting machinery a bolder arrow emerges to the right, pointing forward, *rightward* and up! – into the future. In the book's second chapter, "Dilemmas of Antisystemic Movements," Wallerstein and Co. assert that "the multiple forms of human rebellion" – forces for the good – "have for the most part been only partly efficacious at best…. One continuing sociological characteristic of these rebellions of the oppressed has been their 'spontaneous,' short-term character." They conclude: "This has been one of the great strengths of the world's ruling strata throughout history – the noncontinuity of rebellion." Let us call it the apparent naturalness of the status quo. The task ahead is simple: converge, organize, unite. Let art be of help, perhaps – haltingly, tentatively *show the way*. Out.

Giovanni Arrighi, Terence K. Hopkins
and Immanuel Wallerstein
Antisystemic Movements
No information available Verso, 1989

Transfigurements

On the True Sense of Art

JOHN SALLIS

Zeichen in Gelb is a major work from 1937, made against the darkening backdrop of the impending political catastrophe about to engulf Europe, while privately Klee was fighting the demon of his declining health and rapidly declining motor control. About this work and others like it, John Sallis – a professor of philosophy who edited a volume of philosophical responses to Klee's *oeuvre* and published another book with a Klee cover, titled *Senses of Landscape* – notes, "There are works in which Klee presents the dyad of the said and the seen both in the title and in the picture itself. Such a doubling of the double occurs in the work entitled *Signs in Yellow*, which consists of black sign-like marks set against a background made up of blocks of various shades of yellow." This remark raises the possibility that *Signs in Yellow* could just as easily have been painted in *blue*, or *red*. But it wasn't: Signs mean to signify something, and the "meaning" of Klee's painting may simply be that, yes, we can put our trust in art. It does or depicts what it says. There is, to paraphrase the title of a book by Jacques Derrida that Sallis engages with at some length, "truth in painting."

The aim of Sallis's ambitiously titled *Transfigurements: On the True Sense of Art* is "to show that philosophy needs to attend to art directly." An example of such a *rapprochement* is staged in the book's final chapter, no less promisingly titled "The Promise of Art." Sallis suggests that "the promise of a transfiguring" – the author's titular neologism resembles a secular version of the magic of transfiguration – "advancing towards us from out of the future is attested by the famous lines, often cited by Heidegger, from Hölderlin's late hymn *Patmos*: 'Wo aber Gefahr ist, wächst / Das Rettende auch.' (But where danger is, / That which saves us also grows.) In this paradoxical conjunction or reversal, that which would save promises to emerge in utmost proximity to the very danger it would allay." The childlike innocence and lucid, luminous playfulness of Klee's imagery – once described as a "carpet of life" by its owner, Ernst Beyeler – blooming ever brighter against ever darkening skies: It is precisely the modesty of this homegrown miracle that has made Klee such a dependable source for one-word summations of the *necessity* of art.

Zeichen in Gelb John Sallis

(Signs in Yellow), 1937 *Transfigurements*

Fondation Beyeler, Basel University of Chicago Press, 2008

CONSCIOUSNESS
EXPLAINED

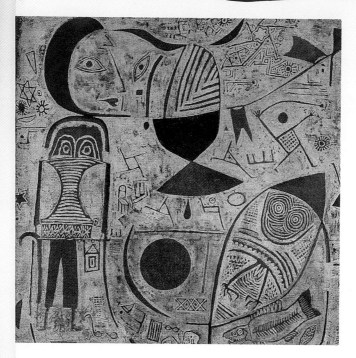

DANIEL C. DENNETT

Author of <u>Brainstorms</u> and coauthor of <u>The Mind's I</u>

Paul Klee painted *Bilderbogen (Picture Album)* in 1937, the same year the Museum of Modern Art in New York organized an exhibition titled *Prehistoric Rock Pictures in Europe and Africa*. MoMA's founding director, Alfred Barr Jr., observed in the preface to the accompanying catalogue (the lead essay was written by the celebrated German anthropologist Leo Froebenius) "that an institution devoted to the most recent in art should concern itself with the most ancient may seem something of a paradox" – but this, after all, was a decade obsessed with points of origin and genealogies, calls to order, and returns to the source. Painted at a time of great physical discomfort, this is Klee's most overtly primitivist nod to the art of cave painting – unique and undoubtedly transformative (no paintings made after this point would return to the frenetic density and delicate filigree of his earlier work): earth-toned gouache on unprimed canvas; primordial marks scratched into rough-edged rock faces; a scaly fish about to conquer land, a bird, and a moon-headed woman.

In *Consciousness Explained*, Daniel C. Dennett seeks to locate the source of that most human of mental qualities – the sense of self. Ever the Darwinist, Dennett traces the emergence of mind back to the mindless dawn of time: "In the beginning, there were no reasons; there were only causes. Nothing had a purpose, nothing had so much as a function; there was no teleology in the world at all. The explanation for this is simple: there was nothing that had interests." Dennett here describes the early universe of so-called "replicators," the basic evolutionary units of genetic time – "things" of such primal abstraction one could easily imagine Paul Klee attempting to capture them in color and lines. Dennett's primeval scene, however, also conjures something of the Idealist spirit in which our idea of art has so long been conceived: without purpose, without function, without interest. It is indeed somewhat surprising (Klee would have concurred) to find not a single mention of the word "art" in the book's expansive index.

Bilderbogen
(Picture Album), 1937
Phillips Collection, Washington, D.C.

Daniel C. Dennett
Consciousness Explained
Back Bay Books, 1991

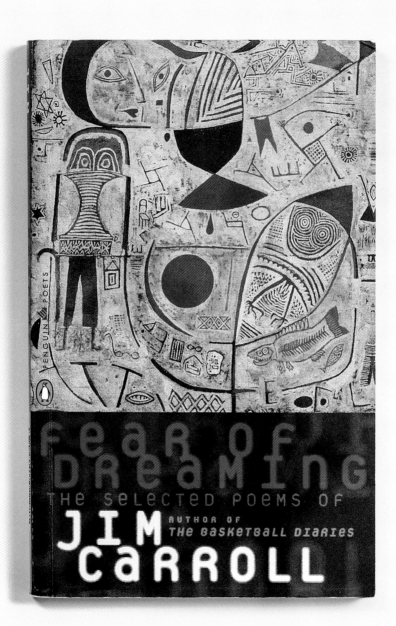

PENGUIN POETS

FEAR OF
DREAMING

THE SELECTED POEMS OF

JIM CARROLL
AUTHOR OF
THE BASKETBALL DIARIES

Paul Klee and poetry – and Klee's *Picture Album* gilding a book of poems by Jim Carroll (author of *The Basketball Diaries*). "At long last!" I am almost inclined to exclaim – Klee was an enthusiastic amateur poet himself (though his poems were never published during his lifetime), and his art, made at a time of much greater proximity between the realms of poetry and visual art, is nothing if not… well, *poetic*. The sparse, skeletal ballet of scratchy lines and scatterings of daubs and splotches across the pages of his finest drawings resemble the reluctant, self-effacing words of an interbellum poem in, say, the Gottfried Benn mold. Yet his imagery is oddly absent from the visual language of twentieth-century poetry, and correspondingly hardly figures on poetry book covers – out of a deep-seated fear of tautology (or being *outclassed*) perhaps? It is, in any case, hard to square the innocence of Klee's image-world with the urbane abrasions of Carroll's verse. (OK, I do get the troglodyte nod.) Better to hear Antonin Artaud out, in "A Painter of the Mind," originally published in 1923:

> In PAUL KLEE
> the objects of the world
> fall into order, –
> and it seems as if he was only
> writing down their dictation.
> An ordering of visions
> of forms
> a fixation and stabilization of thoughts
> inductions, deductions of images
> with the conclusions to be drawn from these,
> also an ordering of images
> a search for the hidden sense
> an illumination of visions in the mind –
> such is, to me, his art.

Or, in Klee's own famous last words, titled "Last Things Last":

> In the heart's center
> the only prayers
> are steps
> receding.

And no fear of dreaming –

Bilderbogen

(Picture Album), 1937

Phillips Collection, Washington, D.C.

Jim Carroll

Fear of Dreaming

Penguin, 1993

JONATHAN LEAR

Open Minded

WORKING OUT THE LOGIC OF THE SOUL

This is of one Paul Klee's last major paintings – only a little less demonstratively aware of the nearing end, perhaps, than his *Death and Fire*, with which it shares a rudimentary (and ill-omened) sense of scattering, fragmentation, decentralization. Its original German title is a fairly neutral *Blick aus Rot*, which could be translated as "View from Red" – why it has become known as the much more charged "Beware of Red" I do not know. Should this translation be read, perhaps, as a not-so-subtle bit of political messaging? Beware of the reds? Watch the red alert? Look out for *blood*? (One of my favorite Jean-Luc Godard quotes remains the immortal, indestructible "It's not blood, it's red!")

A question of projection, in short, or a matter of transference perhaps – so it only seems appropriate that a reproduction of this work, so disorienting and centerless and open to interpretation, should appear on the cover of a book by Jonathan Lear titled *Open Minded*, conceived, in part, as a critical plea for a *retour à Freud* as an inexhaustible source for achieving a better understanding of the structure of human subjectivity in the age of "knowingness." (Jonathan Lear is the director of the research institute that hosted the exhibition which this publication accompanies; I refer the reader to his foreword. When I first proposed an exhibition of Klee-themed book covers to Jonathan, he was quick to conjure this very volume before my amused eyes. One eye open and another shut, I think, sit at the center of Klee's *Beware of Red*; the many meanings of "vision" appear to be this puzzling painting's true subject.)

Thinking and writing at the intersection of philosophy and psychoanalysis, Lear remarks in his preface to *Open Minded*: "Psychoanalysis, Freud said, is an *impossible* profession. So is philosophy. This is not a metaphor or a poetically paradoxical turn of phrase. It is literally true. And the impossibility is ultimately a matter of logic. For *the very idea* of a profession is that of a defensive structure, and it is part of *the very idea* of philosophy and psychoanalysis to be activities which undo such defenses. It is part of the logic of psychoanalysis and philosophy that they are forms of life committed to living openly – with truth, beauty, envy and hate, wonder, awe and dread." To open not just the mind, but body and soul – and Eye and I alike.

I will not wade into the murky water of Klee's relationship to Freud and psychoanalysis – except to say that there was *something* there. And that the essence of Klee's work may well reside in its foundational resistance to identifying "essences" – in its programmatic, never-tiring *opening up* of the field of vision.

Blick aus Rot

(Beware of Red), 1937

Zentrum Paul Klee, Bern

Jonathan Lear

Open Minded

Harvard University Press, 1998

Linear Functions
AND
Matrix Theory

B i l l J a c o b

Admittedly a bit of an outlier – my research into the use of Klee imagery on (predominantly academic) book covers was supposed to remain confined to the humanities and the sprawling macrocosm of "theory"; beyond this one serendipitous find, I have not shopped around much in the math and science sections of the Anglophone world's bookstores and libraries (where to begin?). It is hard to guess what Klee would have thought of the zealous recycling of his work for the aforementioned publishing purposes, but not hard to imagine that he would have been delighted to see his *Blick aus Rot* reproduced atop a primer of linear geometry, basic matrix algebra, Eigenvalues, and Eigenvectors:

$$x_j = , \frac{\det(A_j)}{\det(A)} \text{, for } j = 1, 2, ..., n$$

Which would not have looked out of place in his famed *Pedagogical Sketchbook* from 1925, published while teaching at the Bauhaus, when all around him the natural sciences were transformed beyond recognition by one revolutionary upheaval after another. Perhaps one way of looking at Klee's patterns is as a window onto the world wrought by Gödel, Heisenberg, Hilbert, Schrödinger – as a *Tractatus* in paint.

Blick aus Rot

(Beware of Red), 1937

Zentrum Paul Klee, Bern

Bill Jacob

Linear Functions and Matrix Theory

Springer, 1995

A GUIDE TO
ETHICS AND
MORAL PHILOSOPHY

Brent Adkins

Measuring a mere thirty-five by seventy inches, this well-known late abstract painting, titled *Insula Dulcamara* – its curious substrate newspaper glued to stretched jute – is effectively Paul Klee's largest painting. Where shall we find the painting's titular bittersweet island, this late in life and in the darkening decade that surrounds it? Rumor has it this painting was started as early as 1921, and originally titled *Island of Calypso*, in honor of the seductive nymph of Homeric lore. Script-like marks, eyes, and curlicues traversing a greenish patch of painted garden, perhaps of the traditional Oriental kind: One author has discerned in this painting the artist's own name rendered in quasi-Arabic calligraphy, a symbolic signing off before death.

One could perhaps (reasonably?) have expected a higher frequency of Klee covers in the ethics-and-moral-philosophy sections of one's well-stocked local book peddler. On the other hand, one could perhaps make the case that Klee's aesthetic is too disjointed and dissonant, too angular and fragmentary, too diminutive and meticulous – in one word, too "modern" – to properly convey the totalizing logic of ethics' basic questions: how to live wholly, how to live wholesomely, how to live well. Hence the recurrence of Klee imagery on book covers that have the words "critique" and "critical" in their titles; hence the propensity, among moralists, historians, and theorists of morality – or their publishers at least – to cloak their thoughts in the benedictory garb of, say, a Poussin or David.

In his conclusion to this book's guided tour along the habitual signposts of Aristotle, Spinoza, Kant, Mills, Nietzsche, and Levinas, Adkins avers: "The important lesson in all of this is that philosophy is a life-time task," like tending the disarray in Klee's gardens. (*Insula Dulcamara* stands at the end of a long line of horticultural imagery in the artist's work.) *Il faut cultiver son jardin.*

Brent Adkins
A Guide to Ethics and Moral Philosophy
Edinburgh University Press, 2017

Insula Dulcamara, 1938
Zentrum Paul Klee, Bern

THE
INTENTIONAL
STANCE

Daniel C. Dennett

This is the last of four Daniel C. Dennett books in our selection, and here the relationship between book and cover art is the most direct – the painting in question, completed in 1938, is titled *Intention*. The German title, *Vorhaben*, could also be rendered as "proposal" or "proposition," "purpose" or "scheme" – perhaps even as "enterprise" or "undertaking": a broad range of meanings.

The Stanford Encyclopedia of Philosophy succinctly defines "intentionality" as "the power of minds to be about, to represent, or to stand for, things, properties and states of affairs." I am especially struck here by the phrase "to be about," and "to be about things, properties and states of affairs." A brief chapter in Dennett's book promises "Reflections About Aboutness," but these reflections do not answer the many questions I often have concerning the riddle of "aboutness," especially where it concerns the realm of art – surely one of the most durable citadels of both intention and intentionality available to the human imagination: What is the work of art, really, other than intention in its purest form? Which is perhaps why we are so often inclined, when facing a work of art, to ask of it what it is *about* – the very absurdity of which dawns upon us the very moment this question is asked. (Sometimes asking the question what this or that work of art is about, especially when posed to the artist, can even be a source of mild embarrassment or shame. What is *that* about?) What was the intention behind Paul Klee's *Intention*? Most likely to paint the intended picture. Does this make Klee's painting a meta-artistic reflection, the artist's musing on artistic intent?

Vorhaben is divided in two uneven planes – one colored a dull brown, the other a more uplifting fleshy orange: outside and inside? – bounded by a zigzagging figure endowed with cyclopic vision. (It has been called a self-portrait.) Crude, angular shapes abound left and right, most notably an animal (to the left, looking right) and a running biped (to the right, running away). That seems about it.

Vorhaben
(Intention), 1938
Zentrum Paul Klee, Bern

Daniel C. Dennett
The Intentional Stance
The MIT Press, 1987

Risk, Environment & Modernity

Towards a New Ecology

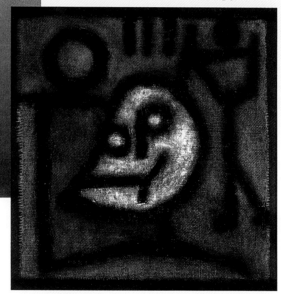

edited by
Scott Lash, Bronislaw Szerszynski
& Brian Wynne

The guiding conceptualizing framework for this collection of essays, compiled at a time (it now feels like) of less apocalyptically pressing ecological concerns, is provided by the German sociologist Ulrich Beck, who famously coined the notion of the *Risikogesellschaft*, or "risk society." According to the editors, "Beck argued that an older industrial society, whose axial principle was the distribution of 'goods,' was being displaced by an emergent 'risk society,' structured, so to speak, around the distribution of 'bads'" – a mirror image, in some sense (Beck does not situate this shift in time), of the modernizing drive from an industrial to a postindustrial society – and from rationality to reflexivity. Somewhere in here, I'd say, there's a crucial part for art to play – something to do with risk and, yes, *play*, or perhaps with "death and fire."

One of the editors' contributions to this reader starts out by stating, quite confidently, that "once, it seems, we knew what to do." And "then came modernity." The bleakness of that moment's meaning is ominously captured in Klee's visual testament, which could not have been painted at any other time.

Tod und Feuer
(Death and Fire), 1940
Zentrum Paul Klee, Bern

Scott Lash, Bronislaw Szerszynski, and Brian Wynne
Risk, Environment and Modernity
SAGE Publications, 1996

HEIDEGGER
AND
LANGUAGE

EDITED BY **Jeffrey Powell**

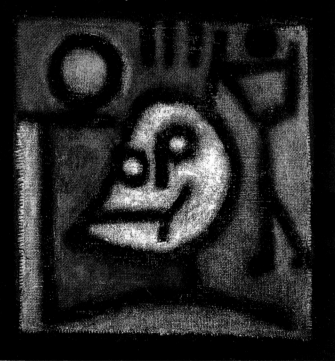

Death and Fire is the last work Paul Klee ever painted, finished shortly before his death on June 29, 1940. It is part of a larger group of works made after the onset of scleroderma in the mid-1930s, a medical condition that severely weakened Klee's command of the finer aspects of image-making; many of the paintings made in the last years of his life are marked by a quasi-hieroglyphic, graphic crudeness. (Pharaonic Egypt, along with prehistoric cave art, had been an iconographic interest of his for some time as well.) The death mask at the center of this rough-and-ready painting on coarse, untreated jute may have been a self-portrait – the artist readying himself for the end announced in the dance of the letter-like figures around the grinning skull (the T, O, and D of the German "Tod"). At the time of the painting's completion in neutral Switzerland, death, of course, was encircling Klee on all sides; the German cities that he had so long called home would soon be reduced to smoldering ash.

A perennial ghoulish favorite at the Zentrum Paul Klee in Bern, it was most likely included in the Klee survey show Martin Heidegger visited in the late 1950s, a dark time, in turn, for the fallen idol of Todtnauberg. (Before Heidegger met the Romanian-Jewish poet Paul Celan in his rustic mountain retreat there in the late 1960s, the latter had already become famous for naming death "a master from Germany.") Exposure to Klee's work after the war famously led Heidegger to briefly consider rewriting parts of his seminal essay "The Origin of the Work of Art" from 1936. Nothing ever came of the plan, which remained stuck in a haphazard pile of "*Notizen zu Klee*" – one of which includes a memorable paraphrase of one of Klee's own quotes: "*Bilder sind keine lebende Bilder*" – images are not living images; paintings are dead: non-beings. This Klee painting in particular must have appealed to Heidegger in its frank embrace of "Being-towards-death," as he was fond of characterizing one of the fundamental qualities of authentic Dasein.

The sternly clenched jaw marking the *Todeskopf* in the middle of the painting suggests something of the true liberating power of death – it delivers us from the despised chatter or "idle talk" (*Gerede*) of "the They" (*Das Man*). "Authentic silence is possible only in genuine discourse," Heidegger wrote – i.e., *in death*. "In order to be silent, Dasein must have something to say, that is, must be in command of an authentic and rich disclosedness of itself. Then reticence makes manifest and puts down 'idle talk.'" *Reticence as a mode of discourse* – this would prove a fruitful strategy for the disgraced philosopher's postwar life. There could hardly be a more fitting seal for the coupling of Heidegger and language *in death* than Klee's famous last strokes.

Tod und Feuer

(Death and Fire), 1940

Zentrum Paul Klee, Bern

Jeffrey Powell (ed.)

Heidegger and Language

Indiana University Press, 2013

Edited by Gordon McMullan and Sam Smiles

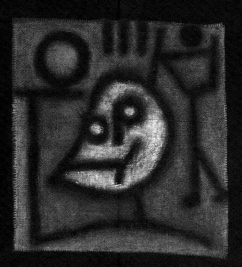

LATE STYLE
AND ITS
DISCONTENTS

Essays in art, literature, and music

OXFORD

This collection of essays considering the idiosyncrasies of the "late style" phenomenon in the work of selected artists, authors, and composers could hardly dream of a more fitting frontispiece than Klee's eerie swan song *Tod und Feuer*. ("Almost from its inception, the idea of late style or late work has been freighted with aesthetic associations and expectations that promote it as a special episode in the artist's creative life," the editors write in their introduction. "Late style is often characterized as the imaginative response made by exceptional talents to the imminence of their death.") The exceptional talents discussed in this volume are, in order of appearance: Titian, George Oppen, Charles Darwin, Pablo Picasso, Gioachino Rossini, Franz Schubert, Goethe, Friedrich Nietzsche, Thomas Mann, D. H. Lawrence, Jane Austen, Maurice Ravel, Michael Hamburger, Ludwig van Beethoven, Claude Monet, and Theodor Adorno (himself the author of a famous four-page essay "On Beethoven's Late Style," as well as the subject of books and essays titled *Exact Imagination, Late Work*, and "Lateness as 'a European Language'"). Remarkably enough, in other words, no Paul Klee.

In his contribution, "The Infinity of Water Lilies: On Monet's Late Paintings," the Norwegian art historian Bente Larsen quotes from Adorno's *Aesthetic Theory*, itself a late work, published (as we know it today) only posthumously: "If there is something like a common characteristic of great late works, it is to be sought in the breaking through form [*Gestalt*] by spirit. This is no aberration of art but rather its fatal [*tödliches*] corrective. Its highest products are condemned to a fragmentariness that is their confession that even they do not possess what is claimed by the immanence of their form [*Gestalt*]." Larsen goes on to suggest, pace Adorno, that "the appearance of the artwork, its 'apparition,' is bound up with 'death,' conditioning *Geist* to appear in what it dissolves instead of what is resolved or synthesized through a dialectics of unity, the Hegelian '*sinnliches Scheinen der Idee*' (sensuous appearance of the Idea)." We are reminded here, once again, of Klee's seminal status as the chronicler par excellence of fragmentation as the irreducible fundament of modern life and polar opposite of the dream of totalization (or its attendant "bigness"). I know of *no* Hegel editions or Hegel studies that sport Klee artworks on their covers. Perhaps an irrevocable realization of fragmentariness as the fate of all life comes with the dawning of lateness.

Tod und Feuer

(Death and Fire), 1940

Zentrum Paul Klee, Bern

Gordon McMullan and Sam Smiles (eds.)

Late Style and Its Discontents

Oxford University Press, 2016

Judging a Book
Susan Bielstein

We don't know when the saying "You can't judge a book by its cover" entered the English lexicon, but no doubt it was recently given that until the 1820s, most books weren't issued with covers at all – if anything, they were purchased in a white paper wrapper or sleeve as temporary protection from dust and handling. It was up to the buyer to have a book bound, which could be an expensive proposition. It was also a subjective one. The owner was at liberty to dress a book up or down according to their taste. There was no moral obligation to commission a cover that conveyed the sense of the text. If you were a browser and wanted to know what a book was about, you were supposed to open it and read for yourself.[1] In other words, there was a clear ontological distinction between the book as text and its protective cover.

1 This is a point driven home by George Eliot in *The Mill on the Floss* (1860, Book 1, Chapter 3) in the conversation between Mr. Tulliver and Mr. Riley about a book that the young protagonist, Maggie Tulliver, has been reading, namely Daniel Defoe's inflammatory *The Political History of the Devil* (1726). Substantively this idiom belongs to a much older family of wisdom sayings based on the mistrust of the Other, especially an Other that is attractive on the surface: "Beauty is only skin deep." "All that glitters is not gold." "A wolf in sheep's clothing." "Clothes don't make the man." Early in the Common Era Juvenal noted in *Satires*, "Fronti nulla fides": "Never have faith in the front."

In the 1830s that began to change: Industrial advances in paper-making and printing meant books could be produced cheaply, putting them within the reach of a growing literate public. Books started to be offered ready-made, already covered. Between 1840 and 1900 the number of books published in Great Britain more than doubled, driving publishers to seek advantages over competitors.[2] One way was to transform the cover from a protective tactic into a marketing lure. All over the British Isles, at newsstands and in train stations, vendors hawked mass-market reading in enticing covers. One particular category was the penny dreadful or penny blood, so named because it cost a penny. These thin booklets sported wood engravings on the cover that promised sensational tales of adventure or terror: a band of savages energetically sawing an explorer in half; a vampire sucking blood from the neck of a docile virgin. My own favorite features the image of a sinister man in sharp-heeled boots and a jacket outfitted with black wings, perched in a tree.[3] What is he doing there, you ask? Pay a penny to find out. These little dreadfuls and their kin – yellowbacks and pulps – were wildly popular, and part of that was due to the cover.

Today's modern book typically sports a coat of many colors, with testimonials by famous authorities ("blurbs") extolling its virtues printed on the back. (The invention of photolithography made it possible to transfer full-color art on to a cover.) The cover design, though primarily an artifice of advertising and consumer

2 See website Bl.uk (British Library): "Aspects of the Victorian Book," Introduction. Chart compiled based on titles listed in *Publisher's Circular* (1840–1900). See also Simon Eliot, "Some Patterns and Trends in British Publishing 1800–1919," Occasional Papers of the Bibliographical Society, 8 (London: the Bibliographical Society, 1994). Simon Eliot and John Sutherland, *The Publisher's Circular 1837–1900: Guide to the Microfiche Edition* (Cambridge: Chadwick Healey, 1988).

3 The character's name is Spring-Heeled Jack. He was featured in newspapers, dreadfuls, and other pulps from 1838 to around 1896. His costume seems to have been a precursor of Batman's, although his motives were less helpful.

psychology, has over time become an integral component of a book's identity. Authors certainly think so. Readers do, too, albeit mostly unconsciously. Because the sight of the cover or dust jacket commonly produces a reader's first impression of a book, she tends to approach it according to the categories suggested by that image. How much of the actual content the cover reflects is, in the end, a matter of degree: Ultimately the publisher's mission is to distill a book's deep subject into a striking surface, a kind of eidetic reduction.

As the covers in this exhibition demonstrate, the art of Paul Klee has a vast, wide-ranging repertoire in graphic design. It can serve as an envoy for just about any modern subject. Publishers love Klee's work: It is at once graphically precise and semantically ambiguous – part of its success is that it invites the viewer to bestow personal meaning on it. Usually that's to a book's advantage, but not always, as I once learned the hard way.

Scholarly publishers take great care with a book's cover design. It is with pride and anticipation that we unpack our freshest titles to show off at academic conferences, like new fashions. A key venue for my list is the annual meeting of the College Art Association, which draws thousands of art historians, students, and artists – individuals attuned to the visual pleasures our books offer. Each year we decorate the University of Chicago Press booth with giant, blown-up posters of book covers. Sometimes we even load an eight-foot-tall light box with the newest cover designs, which glow ecstatically when we plug the contraption in.

Several years ago I was putting the finishing touches on our showcase just as a well-dressed scholar wandered in and began to work her way through the books on display, pausing every few steps to pick one up and inspect the front carefully, then turn it over to read the blurbs on the back.

As anyone who has worked in retail knows, placement is everything. As the scholar came closer, I decided to switch out two volumes, putting a visually

compelling one featuring a luminous painting by Paul Klee (*Ancient Harmony*, 1925) in front of a book in a much plainer cover. I was delighted when the scholar picked it up. The book was not actually about Klee: The presence of his work on the cover had been a solution to a somewhat delicate problem that touched on the proscription against graven images in traditional Judaism. The book, authored by historian Michael Steinberg, bore the title *Judaism Musical and Unmusical*. It was a work of modern intellectual history that emphasized the influence of secular Jewish thought on Western European culture, inflected by notions of musicality; its cases were, by anyone's standard, secular rather than religious. Yet because the title bore the word "Judaism" – which the author had thought more melodious than the term "Jewishness" – we selected a nonrepresentational image for the cover that would evoke the warm tonalities and musical themes of the book without using a graven image. We both thought *Ancient Harmony*, with its abstract pattern of color and sonic textures, fit the bill perfectly.

How smart we had been to choose that Klee, I exulted, watching the scholar fixate on it. She came at me waving the book.

I enthused. "Oh, that's a wonderful study. Hot off the press. What can I tell you about it?" I smiled broadly, but instead of smiling back she metaphorically threw the book at me.

"Such a disgrace," she inveighed. "Shame on you."

I had no idea what she was talking about.

"Klee wasn't a Jew," she said, impatient. "Some think so but he wasn't. What's he doing on the cover?"

I stared at her. "But... the image is just meant to convey a mood."

"What kind of mood? A Jewish mood? It's a Jewish book by a Jewish author. It has a Jewish title. Everything about it is Jewish – why not the cover? Instead, you ruin it with this *schmatta*. What could the author have been thinking to allow it?"

"Actually it was his idea," I blurted, quick to avoid blame. "And, really, it's just an abstract image we used for decoration. For all intents and purposes, it could be by anyone."

"But it's not," she remonstrated. "It's by Paul Klee.[4] You want abstraction? Why not Lissitzky? Why not Rothko? Now there was a man with mood." I could tell there was no changing her mind. She was of the persuasion that the cover really mattered. She was modern. She was moral. For her, the presence of Klee's Gentile confection was a mortal blow to the book's integrity. She gazed at me fiercely over the tops of her glasses, and I gazed back at her over mine. Without another word, I picked up the book and ripped off the cover. I put the book back on display. What was there left for her to do but leave? She did.

As for the book – naked, unbound, but bearing up under the strain – it remained in that spot for the duration of the conference, looking like something you might have bought in the eighteenth century. It *did* draw attention. A number of scholars wanted to know what had happened to it; however, nobody thumbed through it to see what it was about. Nobody bought it either.

Susan Bielstein is the executive editor for art and ancient studies at the University of Chicago Press.

4 I wondered at the time if her displeasure was somehow tied to Klee's monoprint *Angelus Novus* (1920), which had been insinuated into Jewish culture by Walter Benjamin when he used it to describe the fragmentation of history and saw in the image allusions to Jewish mysticism. The artwork now resides in the Israel Museum in Jerusalem.

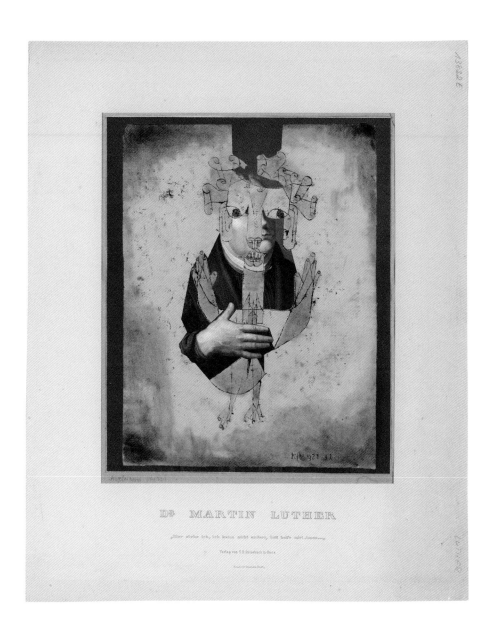

R. H. Quaytman

הקקת, *Chapter 29*, 2015

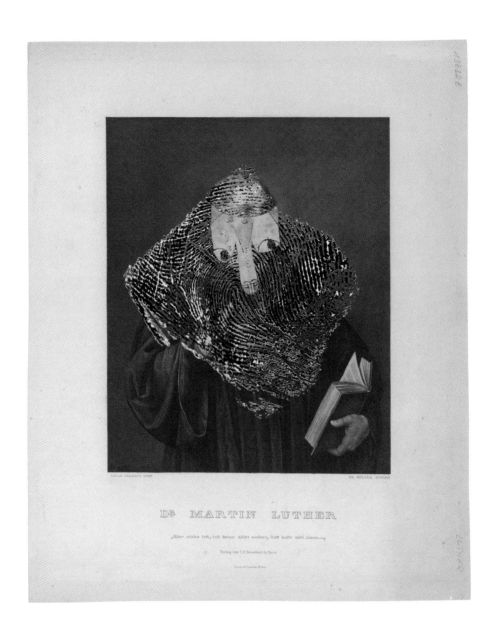

R. H. Quaytman

קקה, Chapter 29, 2015

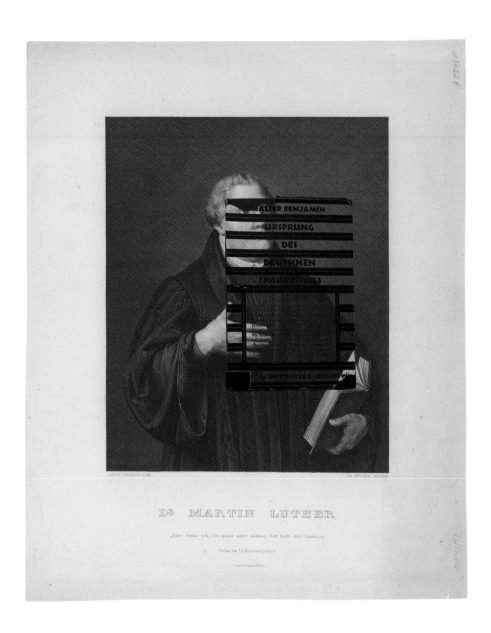

R. H. Quaytman

חקק, Chapter 29, 2015

Paul Klee Among the Philosophers
Dennis J. Schmidt

We are told not to judge a book by its cover, but a well-conceived book cover can say much about the book that follows, and the choice of an image to represent the book on its cover can be of real significance. Without words, images on book covers can make a statement about a book *avant la lettre* so that before the book is even opened something of its promise is announced. Together with the title and the author's name, the cover image tells a reader something about what to expect. There is nothing random about the choice.

As this exhibition makes wonderfully clear, Paul Klee's work is the choice of cover image for a great many philosophers from a variety of traditions. This is revealing, and it is no accident – there is something about Klee's work that speaks so well to the cutting edge of thinking today. In fact, Klee's work continues even into our time to engage the cutting edge of thinking. As Michel Foucault put it, "In relation to our century, Klee represents what Velázquez had been able to represent in his."[1] Foucault's remark is quite true, but it also only scratches the surface of what the choice of Klee really signals for philosophy today. The

1 Michel Foucault, *Dits et Écrits*, vol. 1, *1954–1969*, eds. Daniel Defert and François Ewald (Paris: Éditions Gallimard, 1994), p. 544.

clear affection for Klee's work as an image announcing so many works in philosophy is the consequence of something more than a merely contingent pleasure taken in one artist; rather, Klee's work makes a statement, and there is a reason his work graces so many book covers in philosophy. One of the great merits of this exhibition is that it compels us to ask more precisely just why this is the case and to say more clearly what is said in this choice.

To begin to understand this choice of Klee's work and to appreciate its significance one needs to remember something about the history of the relation of philosophy to painting. Plato set the tone for the history of philosophy that would follow when he said that painting is nothing but a copy of a copy and so painting is something quite far removed from truth. In the end, Plato's claim is that we do not have anything to learn from painting about our world. This argument took hold and so the history of philosophy after Plato has not been attentive to painting. For the most part, the few references to paintings one finds in philosophy texts are made only *en passant* or as minor flourishes that might add a bit of color to a discussion; they are not made in order to learn something through engagement with painting. Generalizing about the history of philosophy is a risky business – contention rather than consensus tends to govern that history. However, it does seem fair to say that for most of that history images, especially painted images, were not taken seriously and not considered a way of thinking about the world; they remained only forms of representation, mere copies of copies.

In the late nineteenth and early twentieth centuries this philosophical dismissal of painting began to change. There were two reasons for this change of heart. First, philosophers began to discover the limits of both philosophical reason and language. As a consequence they began to entertain the possibility that other ways of engaging the world, even painting, could indeed expose something that is not accessible to language. Second, painting became abstract, and this new form of painting made clear that painting

could not be understood as a copy, as a representation of something else. In 1920, Klee made this point well when he wrote, "Art does not reproduce the visible; rather it makes visible." Painters were opening up the possibilities of painting, and they were making evident to all who could see that painting is not to be understood as a matter of copying the world we see but of revealing what has not yet been seen.

In the first decades of the twentieth century painters began to challenge us to see the world anew. Philosophers, so profoundly rooted in theory, needed to be told how to see this challenge, and Klee, who was a teacher, was especially well suited to helping philosophers learn to see what painting could accomplish. So it was Klee's texts as well as his paintings that helped open our eyes. Klee's 1920 essay "Creative Confession" and his 1924 lecture "On Modern Art" were keys that helped others see what language could not accomplish and what images might reveal. Thanks to Klee, and others of his generation, the real originality and challenge of painting that had long been overlooked in the history of philosophy came into view.

The 1930s would be a decisive decade in this revolution in the philosophical attitude to painting. Martin Heidegger and Walter Benjamin would each write essays on the nature of art that would open the question of the work of art in new ways. The radical character of contemporary painting was intuited even by the Nazis: The 1937 exhibition *Degenerate Art* gathered, in order to mock, some of the most exciting artists of the time, and Klee was among that group. The effect of that exhibition was not what the Nazis intended, and what became even more visible was the truly creative and original work of contemporary artists. One of the most dramatic developments in this revolution would come in Benjamin's 1940 text, "Theses on the Philosophy of History," in which he enlists Klee's *Angelus Novus* as the image of the thought expressed in the ninth thesis.[2] What becomes clear in Benjamin's text is that Klee's painting does not serve as an illustration of a thought, but as the way in which a thought emerges.

In 1957, Heidegger visited a recently purchased collection of eighty-eight works by Klee that were privately displayed in Basel, Switzerland. Those works stunned Heidegger, and the enthusiasm with which he engaged them and began to read Klee's writings was unbounded. Heidegger made notes and sketches as he looked at the paintings, and the notes are full of an excitement born of finally seeing what painting could reveal after the "transformation in artwork" that Klee had inaugurated.[3] Full of discovery and eyes newly opened, Heidegger wrote to a friend that "something which we all have not yet even glimpsed before is found in Klee's work."[4] He would tell others that he needed to write a new appendix to "The Origin of the Work of Art" after seeing Klee's paintings. Heidegger's discovery of Klee was clearly a decisive moment in the development of his thought as a whole.

It is difficult to say precisely what Heidegger saw in Klee's paintings – his notes are matched in their enthusiasm by their opacity. However, this much is clear: What Heidegger saw in Klee's work, what he learned to see, was something far outside of the orbit of seeing painting as a copy of something or simply as a matter of representation. What he saw was far removed from what Plato argued was to be seen. Thus, one reads Heidegger writing "not images – rather states. No more mere eidos, and nothing present, no object." And Heidegger came to understand something new about beauty as well: These works were beautiful not because of some sense of classical harmony or resonance

2 Benjamin had purchased this work by Klee in 1921 and it is clear that this image of what Benjamin called the Angel of History had a profound effect upon Benjamin's understanding of the logic of history. While Benjamin's text was composed in 1940, it would not be published until 1947.

3 Those notes have been published in both German and English in *Philosophy Today* Vol. 61, no. 1 (Winter 2017). All of the citations of Heidegger's notes on Klee are from this publication.

4 Heinrich Petzet, *Auf einen Stern zugehen* (Frankfurt: Societäts-Verlag, 1983), p. 158 (letter of February 21, 1959).

with the world, but because they made visible the coming into being of a world. That is why Heidegger writes of Klee: "The beautiful – an event." In Klee's paintings it was not the object but the movement of life that one came to see. Maurice Merleau-Ponty would echo this point when he said of Klee's painting that it gives us the "blueprint of the genesis of things."[5]

Of course, Klee is not alone among painters who have stimulated philosophers and have opened new avenues for seeing and understanding the world. The list is long and, happily, growing all the time. From van Gogh to Cezanne, Marc and Kandinsky to Twombly and Kiefer, painters have helped open the eyes of those philosophers who have come at last to understand that to paint is not to represent something else but to think in a way that is different from philosophy, which is forever tethered to words.

And yet, Klee's work will always be among the first and the most radical to show us that to paint is indeed to think. Since opening this new understanding of the world we see and how we can think about it, Klee made it clear to philosophers that a larger sense of the reach of thinking and of the life of the world is needed. Enlarging the possibility of seeing, Klee's work has expanded and transformed the task of philosophy.

It is true that we cannot judge a book by its cover, but it is equally true that book covers and their images tell us something about what a book wants to be, how it wants to be judged, and even what it might promise. Placing a work by Klee on a book cover makes a clear statement. One hesitates to reduce that statement to words, but it does seem fair to say that an image by Klee signals something of an aspiration: to see the world anew, to open up the world, and to make philosophy aware of how large its task really is.

Dennis J. Schmidt is an American philosopher living in Australia, where he is Research Professor and Chair at Western Sydney University.

5 Maurice Merleau-Ponty, *L'Oeil et l'Esprit* (Paris: Éditions Gallimard, 1996), p. 62.

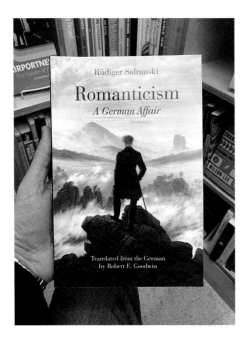

Traveller looking over the Sea of Fog (c. 1818)
Oil on canvas, 94.8 x 74.8 cm
Hamburg, Kunsthalle

According to tradition, the figure depicted here is a certain Herr von Brincken. Since the figure cannot be identified with certainty, we are led to conclude that this picture is a memorial to someone who had recently died. This is the only way we can explain the almost statuesque appearance of the man – so very different from the self-portrait in the *Mountain Landscape with Rainbow*. The traveler in this picture has left the fog-shrouded depths behind him and has climbed to the summit of the mountain. He symbolizes the man who has reached the ultimate goal of his life. The mountain peaks he sees jutting out of the fog are symbols of God. The slight turn of his body to the left indicates that he is facing the large, conical peak in the background, the same Rosenberg that Friedrich had already used in the *Mountain Landscape with Rainbow*. The shape of this mountain is anticipated in the man's sloping shoulders and the other rock formations are also related to the figure. He stands at the point where all the diagonals in the picture converge. His head echoes the strange protruding crag on the right. The row of sandstone rocks, taken from Saxon Switzerland (a mountainous area south of Dresden), are a formal continuation of the hem of his coat. The figure is linked to the landscape in a way similar to the *Woman in front of the Setting Sun*, and has a distinct air of finality about it; this landscape is even less conceivable without a figure than the preceding plate. In this way Friedrich represents the state of eternal life and the fact that man is created in the image of God. This is an extraordinarily daring thing to attempt, and it explains the forcefulness of the composition, especially the way in which the mountain ranges and the bold shapes of the individual peaks are built up.

Helmut Borsch-Supan, *Caspar David Friedrich*, Munich: Prestel, 1974, 110.

Photograph by the author

HOCHLAND
A Plea for Elevation
Dieter Roelstraete

To see the world as cleft into two opposing poles –
that is Spirit. All monism is tedious.
Ludovico Settembrini in Thomas Mann, *The Magic Mountain*

I.

Important information it is – most probably – not, and an original choice it is – most certainly – neither, but Caspar David Friedrich's *Wanderer Above the Sea of Fog* (1818, and long since owned by the Hamburger Kunsthalle) truly is one of my favorite paintings, if only because no single image comes quite as close to capturing, defining, and/or embodying the "original" Romantic spirit in European culture – that singular moment in the historical development of (Western) art that first taught us the primacy of the *idea* of art over its actual execution, *the precedence of theory over practice*, and in the shadow of which we live and work today. From the dizzying heights of the idea of art, the artist – if we take the *Wanderer Above the Sea of Fog* to be a self-portrait, of sorts (it certainly is a portrait of *me*) – literally, not merely metaphorically, looks down upon the *work* of art, i.e., the work that *is* art – the laborious navigating of the nebulous landscape of "production."

That is to say, Romanticism (especially in its German incarnation, as an art movement that is inconceivable without the contemporaneous revolution in thought

marked by the advent of German Idealism) signifies ground zero for all art criticism and art theory, for all thinking and writing *about* art as (potential) *art forms in their own right*. And consequently, to possibly even surpass art: No wonder that I have often dreamt of roaming the cobblestoned streets of Jena anno 1800, that singular moment in the historical development of (Western) art that tempted Hegel into the grandiose, apocalyptic declaration of its "end." See, for instance, the following oft-quoted witticisms from paragraphs 16 and 18 of his *Introductory Lectures on Aesthetics*: "Thought and reflection have taken their flight above fine art... the science of art is a much more pressing need in our day than in times in which art, simply as art, was enough to furnish a full satisfaction." Or, in the words of his tormented traveling companion Friedrich Schelling, writing in his *Philosophy of Art*: "When such a fortunate age of pure production has passed, reflection enters, and with it an element of estrangement. What was earlier living spirit is now transmitted theory." The phrase "pure production" is especially noteworthy here, as Schelling already points the way to the imminent turn, in art discourse, towards a state of so-called *post-production*. "Reflection enters, and with it an element of estrangement": This too could be read as describing the event recorded in Friedrich's iconic painting.

Not surprisingly, and German history being what it is, I am not the only one to have been enchanted over time by this dramatic yet modest evocation of man's fateful showdown with the sublime. (If that's what it is, among many other things.) As I have noted elsewhere, while discussing matters of a related nature, Friedrich's fearless amateur-mountaineer "graces countless book covers on or related to the subject of Romanticism, from Paul Johnson's *Birth of the Modern* (on the Right) to Terry Eagleton's *Ideology of the Aesthetic* (on the Left) and all the Nietzsches and Schopenhauers in between, and he also appears on many

a classical music album cover (Beethoven, Schubert, Schumann)" – mostly of the solo piano variety of course. (As it so happens, I am writing this down on the 200th anniversary of Robert Schumann's birthday, June 8, 2010. And the "elsewhere" referred to above is an essay titled "Ten Tentative Tenets (Jena Revisited)," part four in an ongoing series of texts published in *e-flux journal*.)

More recently, I have also spotted Friedrich's iconic image on the cover of a book simply titled *Die Deutschen*... Nationality aside, "the identity of the wanderer imperiously looking down upon a sea of clouds – a singular mark of his individuality – is shrouded in historical mystery," as is the exact location of this primal scene of European intellectual history, though some of the geological landmarks in the distance have been identified as belonging to the southeast German region of Saxon Switzerland. With the highest point in this range barely making the 2,400 feet mark, it becomes rather difficult to resort to the standard interpretation of such stock Romantic imagery (the obvious complement in Friedrich's own *oeuvre* would be his *Monk by the Sea*, from 1809) as symbolic of man's powerlessness in the face of nature's awesome, overwhelming force. (Modern mountaineering is habitually said to have begun with the successful ascent of Mont Blanc, a feat first undertaken by one Horace-Bénédict de Saussure in 1786; already in 1808, a full ten years before Friedrich painted his *Wanderer Above the Sea of Fog*, Marie Paradis clinched the honor of being the first woman to have made it to the summit of Mont Blanc at 15,781 feet.)

The painting, made in the same year that saw Beethoven embark on the epic journey of his ninth and final symphony (as well as the publication of Mary Shelley's *Frankenstein* and Lord Byron's *Don Juan*), really seems more of a paean to the power of the individual to rise above the cursed condition of "natural" circumstance – a tribute to the

fantastic, dizzying clarity afforded by both distance (or at the very least distantiation) and loneliness.

The opening sentence of Immanuel Kant's epochal *Beantwortung der Frage: Was ist Aufklärung*, from 1784, (so two years before the aforementioned landmark in alpinist history), stating that "Enlightenment is man's release (or emergence) from his self-incurred tutelage (or immaturity)," metaphorically anticipates the literal upward movement of Friedrich's *Wanderer* – if man's self-incurred tutelage or immaturity could indeed be said to resemble a sea of fog. [Yes.] Continuing our ramble through the undulating Swiss countryside, we are also reminded here of Wilhelm Tell's stoic assertion that "der Starke ist am mächtigsten *allein*," as Friedrich Schiller (who famously penned the *Ode to Joy* immortalized by Beethoven in his aforementioned Ninth Symphony) puts it in his 1804 play about the Helvetian crossbow-wielding folk hero. (Let there be no confusion or mistake: I am *not* a mountain-climbing type, but more like another Kant, pondering the sublime from the safety of his rocking chair in a Koenigsberg he never once in his lifetime even dared to leave. My interest concerns the alpine *optic* alone – the epistemological drama of the aesthetico-metaphysical viewpoint.)

Minute the green-frocked figure leaning on his cane may appear to be, but at least this wanderer stands *above* the sea of fog, *outside* the world, *far* from the madding crowd: a marginal figure maybe, but commanding the decidedly Olympian viewpoint of old nonetheless – safely seceded, "up here," from the middling mainstream "down below," that muggy quagmire of mediocre confusions and aimless ambivalences that continuously justifies its stifling hold over our imagination by reverting to tiresome philosophical clichés about the impossibility of the outside view, of being *outside* as such. (Which, depressingly, art has done so much to reproduce and replicate of late, even

though its historical role has long been defined by its dedication to imagining an *outside* – a margin. Or *out-topos*.) Granted, there may perhaps be no such "place" as that which Derrida tauntingly called the *hors-texte*, but a *dehors* exists nonetheless – if only because it *has* to exist for the world to make sense: such an *hors-monde* must exist, in an *onto-theological* sense (to which we will be returning at a later stage in this climb).

The wanderer stands opposed, and opposite, savoring the blessings, mixed or not, of *distance* – no longer enveloped in shadows and fog, the mountain peak from which he peers down to the world below gleams in the light of reason, where all contours are rendered with crystalline clarity (one of the trademarks of Friedrich's craft); his is the detached, slightly chilled viewpoint of the loner, lonely at the top (for that, *in art*, is where we are, no matter how ornamental or irrelevant the art which brought us "there"), and outsider, happily sidelined so as to better observe the stormy confusion of events that constitute "the world." If the artist can perhaps no longer claim such a position or role (though art as such and art in general – as *idea* – may continue to be like a craggy outcropping on the earth's generally smooth, "striated" surface), at least we "others," modeling ourselves after the nameless wanderer, can – and so scale art's remote and rocky peak in turn.

As Susan Sontag put it in her *über*-stylish reflection on style *On Style*, just after having called the work of art "an object, not an imitation": "all great art is founded on distance, on artificiality, on style, on what Ortega calls dehumanization. But the notion of distance is misleading, unless one adds that the movement is not just away from but also toward the world" – eventually, the wanderer will have to descend (for fog, inevitably, is *where life is*) and tell the world about his encounter with the many splendiferous wonders of alpine isolation, if only to remind himself that an "elsewhere" exists, that this

world he or she is bringing his or her good news to is not the only world – it has outsides, exteriors, other places that are (still, or again) worth "believing" in: *exiles*. (*The wanderer is a wonderer.*) The alpine allegory, then, offers an appropriate variation on the basic pyramidal structure of most social worlds (including that world called the art system), where – once flipped on its side, whether clockwise or counterclockwise – edge (border, margin, periphery) and top (acme, pinnacle, summit) become interchangeable in their willed remove from the center, mainstream, middle: spatial metaphors that matter, and continue to work their magic of oppositions.

II.

If you want to get to the peak, you ought
To climb without giving it too much thought.
Friedrich Nietzsche, *The Gay Science*

Thomas Mann's *The Magic Mountain* is, besides one of the greatest novels of the twentieth century, many things, but more than anything else – and this, surely, must have been what attracted the attention of Georg Lukács, Mann's greatest critic and most perspicacious reader, to it – it is a study *in* and *of* dialectics: the dialectical imagination "at work," whether – to borrow the dominant modes of novelistic action – loafing about, rambling, or plainly supine (this too, in the dialectical imagination, can constitute "work").

A colleague and friend of mine whose opinion in these matters I value almost as much as his reading habits recently complained to me about my use of the term "dialectic," calling it "so off-putting a word... a bit like 'dentist.'" This remark initially baffled me because, to my ears, "dialectics" doesn't sound anything like the admittedly off-putting "dentistry" (the source of a deeply seated personal phobia – and I do admit that "dialectics"

sounds like "diagnosis" – but what is wrong with *that*?
It is gnosis, after all: *real* knowledge) – but surprise me it
did not, of course, for what are our current post-political
and post-ideological times other than *post-dialectical*
times, in which all clear-cut ideological oppositions have
become dissolved in a proverbial sea of fog that has
succeeded in convincing all those who are caught in it that
this sense of inescapable immersion is the one defining
characteristic of post-ideological times precisely?

Mann's epic novel of ideas is crisscrossed by a densely layered
network of narrative arcs, many of which can indeed be
defined in terms of theses, antitheses, and syntheses. I will
name only the most obvious for now: body versus mind,
seeing as the novel is set against the backdrop (if we can call
it that) of a cosmopolitan sanatorium for wealthy tubercular
patients; masculine intuitions versus feminine instincts;
eros contra *thanatos* (the twelve years Mann spent writing
the novel saw the gradual popularization of psychoanalytic
lingo in the European cultural imagination: *The Magic
Mountain* was published in 1924, Sigmund Freud's *Beyond
the Pleasure Principle* in 1920, and the story is littered with –
mostly disparaging – offhand references to the so-called
"talking cure"); the battle between Ludovico Settembrini (the
loquacious enlightened humanist, hailing from sun-kissed
Italy) and Leo Naphta (the saber-rattling Jesuit, a converted
Jew who sings the praise of the Spanish Inquisition) over
the guileless soul of Hans Castorp, the novel's bland "hero"
("Hans Castorp chose to regard his own poor soul as the
object of their dialectic rivalry"); "Eastern" vice versus
"Western" virtue; Prussian ("Northern") pragmatism
versus something akin to Catholic ("Southern") indulgence;
and, most importantly and persistently, "up here" versus
"down there," lowlandish stuffiness versus icy mountain
air: wanderer versus everyone else – the "they." Indeed, as
soon as Hans Castorp arrives in the Berghof Sanatorium in
Davos – the present-day site of the World Economic Forum's
yearly summit, ironically enough – to visit his ailing cousin

Joachim Ziemssen, a young man of terrifically humorless military earnestness, it immediately becomes clear to him that the Berghof's (admittedly mild) geographical elevation makes for a very different philosophical atmosphere, one that quickly reveals itself to be almost entirely irreconcilable with the quintessentially "horizontal" virtues of his own solid but stodgy middle-class upbringing in the low-lying Baltic North.

Thomas Mann is one writer who will definitely not be remembered for the effort put into masking the deeply autobiographical nature of much, if not most, of his writing: Like Mann himself, and like the eponymous family whose demise he chronicled in his first major novel, *Buddenbrooks*, Hans Castorp hails from the northern Hanseatic town of Lübeck, a traditional bulwark of mercantile reason; the "Catholic" or "Southern" taste for passionate living and thinking which Castorp encounters in some of the sanatorium's most memorable characters (and which he is thereafter tempted to cultivate in his own soul) is a thinly veiled homage to the temperamental flipside of both Mann's own ancestry (the "nervous" disposition of his Brazilian-born, Roman Catholic mother) and that of his wife, Katia (born into an assimilated Jewish family in Munich); furthermore, the idea of setting what would initially have been only a short story in a swanky alpine health resort first came to Mann when he visited his wife in Davos during her own prescribed stay there in May 1912. Exactly like Hans Castorp, who assures the sanatorium's presiding doctors that he is in perfect health and only visiting a convalescent family member, Mann started feeling feverish shortly after arriving, caught a cold – at 5,200 feet, the Berghof is in fact more than double the height of the peaks depicted in Friedrich's *Wanderer Above the Sea of Fog* – and was eventually told by a similarly insistent physician that he had "a moist spot in his lung."

Here are some samples of the many conversations through-
out the book that touch upon the remarkable dichotomy
referred to above:

> [*Joachim, to Hans, upon the latter's arrival in Davos-Dorf*]:
> "Three weeks are nothing at all, to us up here…. You with your
> 'going home in three weeks.' That's the class of ideas you have
> down below…. They make pretty free with a human being's
> idea of time, up here."

> [*Joachim*]: "Sometimes I think being ill and dying aren't
> serious at all, just a sort of loafing about and wasting time; life
> is only serious down below. You will get to understand that
> after a while, but not until you have spent some time up here."

> [*Hans, talking to his self-appointed guardian, Ludovico
> Settembrini:*] "No, I don't think you, for instance, as homo
> humanus, would feel very comfortable down there…. It is a
> cruel atmosphere down there, cruel and ruthless. When you
> lie here and look at it, from a distance, it makes you shudder."

> [*Settembrini, talking to Hans, whom he is intent on reminding
> of his civic status "down there"*]: "Irony, forsooth! Guard
> yourself, Engineer, from the sort of irony that thrives up here;
> guard yourself altogether from taking on their mental attitude!
> Where irony is not a direct and classic device of oratory, not
> for a moment equivocal to a healthy mind, it makes for
> depravity, it becomes a drawback to civilization, an unclean
> traffic with the forces of reaction, vice, and materialism. As
> the atmosphere in which we live is obviously very favorable to
> such miasmic growths, I may hope, or rather, I must fear, that
> you understand my meaning."

Truly the Italian's words were of the sort that seven weeks ago,
down in the flat-land, would have been empty sound to Hans
Castorp's ears.

Tragicomically, Settembrini himself never manages to return to the flatland, the virtues of which he tirelessly continues to extol over the magic mountain's many vices. Although Settembrini himself would have balked at the comparison, it is hard not to think of Friedrich Nietzsche's similarly tragicomic life story in this regard – and Nietzsche truly is the ghost in Mann's magic machinery.

> [*Settembrini*]: "I beg you, my young friend, not to adopt the phrases current up here, but to speak the language of the European culture native to you. Up here there is too much Asia. It is not without significance that the place is full of Muscovite and Mongolian types. These people –" Herr Settembrini motioned with his chin over his shoulder – "do not put yourself in tune with them, do not be infected with their ideas; rather set yourself against them, oppose your nature, your higher nature against them; cling to everything which to you is by nature and tradition holy, as a son of the godlike West, a son of civilization: and, for example, time. This barbaric lavishness with time is in the Asiatic style; it may be a reason why the children of the East feel so much at home up here."

> [*Leo Naphta, conversing with Hans*]: "I heard you," Naphta answered. "I caught your words and turned round. Were you talking politics, discussing the world situation?"

> "Oh, no," laughed Hans Castorp. "How should we come to be doing that? For my cousin here, it would be unprofessional to discuss politics; and as for me, I willingly forgo the privilege. I don't know anything about it – I haven't had a newspaper in my hand since I came."

> Settembrini, as once before, found this reprehensible.

So what about Nietzsche, the improbable philosophical patron saint of all mountain climbing? Was not his Zarathustra (I know of at least one edition that has

Friedrich's *Wanderer* on its cover, though an alpine painting by the much less well-known Wenzel Hablik adorns a more recent edition) a mountain creature through and through – or at the very least the creation of a deluded mind low on oxygen and high on aesthetic stimuli? Like Kant "pondering the sublime from the safety of his rocking chair in a Koenigsberg he never once in his lifetime dared to leave," Nietzsche preferred to *think* about mountains rather than (blasphemy!) climb them – so as to better grasp the true meaning of the distant and remote: As he himself puts it in Book One of *The Gay Science*: "We had forgotten that some greatness, like some goodness, wants to be beheld only from a distance and by all means from below, not from above" – "up there," most thinking will become exceedingly difficult.

III.

It has long been a well-established fact of twentieth-century literary lore that Thomas Mann based the character of Leo Naphta ("He was small and thin, clean-shaven, and of such piercing, one might almost say corrosive ugliness as fairly to astonish the cousins. Everything about him was sharp: the hooked nose dominating his face, the narrow, pursed mouth, the thick, beveled lenses of his glasses in their light frame, behind which were a pair of pale-grey eyes – even the silence he preserved, which suggested that when he broke it, his speech would be incisive and logical") on Georg Lukács, best remembered today as one of the founding fathers of the philosophical tradition of "Western Marxism," but for most of his active life known primarily as the leading apologist of an already then outmoded conception of literary realism. To fully appreciate the chilling brutality that inspired Mann to model Naphta after Lukács (whose life was at some point quasi-saved by the concerted efforts of the Mann brothers), we should look no further than the preface

which Lukács wrote to his best-known work, *History and Class Consciousness* (published in 1923, just one year before *The Magic Mountain*, when Lukács was my age), in which he defends dialectics as a historical practice based on a concept of transcendence that is essentially *violent* in its pitiless disregard for anything that may appear to interrupt or deflect our joint march towards triumphant totality: "It is of the essence of dialectical method that concepts which are false in their abstract one-sidedness are later transcended (*zur Aufhebung gelangen*). The process of transcendence makes it inevitable that we should operate with these one-sided, abstract and false concepts. These concepts acquire their true meaning less by definition than by their function as aspects that are then transcended in the totality."

Such passages, with their intimations of the impending onslaught of Stalinist terror from which Lukács, at the time at least, had some trouble distancing himself, must doubtlessly have inspired Susan Sontag to write the following in her portrait of Lukács, published in *Against Interpretation* (dated 1964): "We may be generous towards the 'late' Lukács only at the price of not taking him altogether seriously, of subtly patronizing him" – exactly as Mann did, by transforming him into a hysterical novel character – "by treating his moral fervor aesthetically, as style rather than idea." (An intriguing suggestion, seeing as Sontag would later become known for her vigorous defense of the fundamental indivisibility, in literature, of "style" and "idea.")

Sontag also notes that "Lukács has a great talent for personal and political survival – that is, for being many things to many different men. He has, in effect, accomplished the difficult feat of being both marginal and central in a society which makes the position of the marginal intellectual almost intolerable" – an echo, of sorts, of my own characterization of the (high-) cultural

practitioner as a wanderer blissfully lost in Caspar David Friedrich's alpine *tableau*. "To do this... he has had to spend a great deal of his life in one or another form of exile." Friedrich's *Wanderer* predictably graces a number of studies devoted to Mann's *Zauberberg* (one of which, edited by Stephen Dowden, features an essay by Sontag titled "Pilgrimage"), but I know of no editions of the novel itself featuring this most emblematic image.

Leo Naphta's rabid moral fervor is equally treated as an aesthetic affect (or *effect*) primarily; like his foe Ludovico Settembrini, the raging Jesuit does not appear to be in a terrible hurry to reconnect with life in the lowlands, where his doctrinaire ramblings could easily be put into bloody practice – his dialectical stance can really only flourish in rarefied mountain air, in the sanatorium's Nietzschean fantasy world. And here, Mann's novel lives up to its fame as the most damning portrait of Weimar Germany ever painted – a fractured society brimming with hyperbolic radicalisms left, right, and center, all spiraling out of control, waiting to be ignited by less literary, more action-prone men, minds of the lowlands and horizontality. Anyway, let us turn to the following (arbitrary) selection of Naphtaniana, some of which truly are the forbidden delights that Mann was perversely unable (or unwilling) to put into the mouth of the Jesuit's Italian sparring partner:

> "No... Liberation and development of the individual are not the key to our age, they are not what our age demands. What it needs, what it wrestles after, what it will create – is Terror."

> "It is an unloving miscomprehension of youth to believe that it finds its pleasure in freedom: its deepest pleasure lies in obedience."

> "Opposites... may be consistent with each other. It is the middling, the neither-one-thing-nor-the-other that is preposterous. Your individualism, as I have already taken the liberty of remarking, is defective. It is a confession of weakness."

"It would be the first step towards true liberty and love of humanity to free one's mind of the flabby fear engendered by the very mention of the word reaction."

"But in reality, God and the devil were at one in being opposed to life, to bourgeoisiedom, reason and virtue, since they together represented the religious principle."

"Naphta declared that matter was so bad a material that the spirit could not be realized within it."

"Was not the idea of a material world existing by and for itself the most laughable of all self-contradictions?"

"Only out of radical skepticism, out of moral chaos, can the Absolute spring, the anointed Terror of which the time has need."

"God." "Terror." "The Absolute." And so Settembrini's petulant (and, philosophically speaking, ultimately powerless) protestations in defense of democracy, which, however enlightened, fail to fully convince Hans Castorp mainly because of the Italian humanist's refusal of all radicalism (as an assertion, that is, of *radices*: roots, *foundations*), not only echo the tragedy of the Weimar constitution's failure to galvanize the political imagination of the broad left to which the likes of Georg Lukács belonged – they also presage the fateful coming of the so-called "theopolitical" hour. Two years before *The Magic Mountain* and one year before *History and Class Consciousness*, the German intellectual scene had already witnessed the publication of the immensely influential essay "Politische Theologie" by the German jurist Carl Schmitt – a name inexplicably absent from most, if not all, cultural-historical analyses of Mann's monumental *Bildungsroman*, yet all the more present in current cultural-political debates.

In a 1952 letter to a French professor of German literature named Pierre-Paul Sagave in which Thomas Mann implored his critics not to draw too much attention to the perceived resemblances between Leo Naphta and Georg Lukács ("The combination of communism and Jesuitism that I have created there may well be an intellectually sound one, but it has nothing to do with the real Lukács"), Mann also emphatically denies the existence of any consciously sought similarities between Naphta and the Nazi jurist Carl Schmitt – he even claims to have had no knowledge at all of Schmitt's existence, let alone his writings. Unperturbed and unimpressed, Sagave went on to describe Naphta as a cross between Lukács and Schmitt nonetheless (in his *Réalité sociale et idéologie religieuse dans les romans de Thomas Mann*, published in 1954 – just a year before Mann's death north of Venice).

In his aforementioned essay from 1922, Schmitt infamously stated that "liberalism" – the democratic experiment undertaken by Weimar Germany – "had no political content and was only an organizational form," and that "the state is neither the creator, nor the source of the legal order," leading him to conclude that "all significant concepts of the modern theory of the state are secularized theological concepts not only because of their historical development, but also because of their *systematic structure*.... The exception in jurisprudence is analogous to the miracle in theology." This notion of the "exception" is the true heart of Schmitt's polemical claim, which opens with the notorious assertion that "sovereign is he who decides on the exception" (or "state of exceptionality") – he who decides *when* is the right time (or *where* is the right place) to break through the traditional barrier of law. Such a "revolutionary" decision (as to who is a friend or ally and who is an enemy, for instance) is analogous to the divine deed of *creatio ex nihilo*, elevating the lawgiver in question to the status of omnipotent deity – or, as the proto-fascist apologists of

the total aestheticization of politics understood so well, to the status of *artiste*.

Interestingly (but not so surprisingly, given that the early years of the Weimar republic were characterized by boundless onto-political speculation – think of Oswald Spengler in particular – and ludic experiments in radicalism of all kinds), the initial response to the publication of Schmitt's landmark text was rather subdued – the first reaction came from the Catholic mystic-cum-Dadaist Hugo Ball (!), who in 1924 published his "Carl Schmitt's politische Theologie" in the aptly named journal *Hochland*.

And incidentally (anything more would lead us much too far astray): Consider the many resemblances here with the developing thought of Schmitt's near-exact contemporary counterpart in Weimar-era philosophy, Martin Heidegger, whose infamous "Das Man" – the deplorable, formless "they" that people/s the undergrowth of his *Being and Time* (published in 1927, three years after *The Magic Mountain*) – echoes so much of the language of the myriad up-here/down-there hierarchies engendered by Friedrich's *Wandererfantasie*, most notably in Mann's mountain world. (Mann, Man! Should it come as a surprise that one of the most momentous philosophical encounters in Heidegger's life took place in the Swiss mountain resort of Davos, that is to say, the real-life setting of Mann's *Zauberberg*? I am referring here to the carefully staged public confrontation, in the spring of 1929, between Heidegger and Ernst Cassirer, between self-styled German peasant and urbane Jew hailing from northern, flatland Hamburg.) True, i.e. truly *elevated Dasein*, in Heidegger's view, *belongs to the peaks. Being and Time* was partly conceived, of course, in Heidegger's mountain hut in the Black Forest village of Todtnauberg. Though hardly the picture of high-altitude desolation,

the philosopher's famed retreat sits at an elevation of some 4,000 feet – again, higher than Friedrich's originary awesome vista. It is presumably also "up there" – above a sea of fog of sorts – that the basic thrust of his essay "The Origin of the Work of Art" must have taken shape… We do not know whether Heidegger ever gave Friedrich much thought (likely not – the great artistic revelations in a long life of modest visual stimulation and aesthetic sophistication were limited to Vincent van Gogh's painting of a pair of worker's shoes and, postwar, the work of Paul Klee), though it is somewhat surprising that, as far as I know, Friedrich's epochal homage to the Olympian perspective of early modern mountain man never made it to a single Heidegger book cover.

To break through the traditional barrier of law – to scale the *Übermensch* heights, *to reach the summit*, out of the mist's groping reach. To stand in the blinding light of the exception, when only the shortest of shadows is cast – to both stand outside (above, beyond, in any case far removed and away: *opposite*) and understand the necessity of an exterior legitimation to the order of things imposed upon as the worldly state of affairs, and from which one can indeed extract oneself – though perhaps *only through art*. (An indictment of the world around and below us as much as an estimation of this idea of art.) Friedrich's image of splendiferous isolation through elevation casts art precisely as this magic mountain range – the only "thing" (or place) today that we can really *go to* still – to be *away*.

Berlin, Summer 2012

Bibliography

Peter Gordon, *Continental Divide: Heidegger, Cassirer, Davos,* Harvard: Harvard University Press, 2012.

G. W. F. Hegel, *Introductory Lectures on Aesthetics* (trans. Bernard Bosanquet), Harmondsworth: Penguin Books, 2004.

Fredric Jameson, *Valences of the Dialectic,* London & New York: Verso, 2009.

Immanuel Kant, "What Is Enlightenment?" (trans. Mary J. Gregor), in: Olga Gomez et al. (eds.), *The Enlightenment: A Sourcebook and Reader*, London: Routledge, 2001.

Nitzan Lebovic (ed.), 'Political Theology' special issue of *New German Critique* n° 105, Durham: Duke University Press, 2008.

Georg Lukács, *History and Class Consciousness* (trans. Rodney Livingstone), Cambridge, Mass.: The MIT Press, 1972.

Thomas Mann, *The Magic Mountain* (trans. H. T. Lowe-Porter), New York: Alfred A. Knopf, 1927.

Judith Marcus, *Georg Lukács and Thomas Mann: A Study in the Sociology of Literature*, Amherst: Humanity Books, 1994.

Friedrich Nietzsche, *The Gay Science* (trans. Walter Kaufman), New York: Vintage, 1974.

Friedrich Schelling, *The Philosophy of Art* (trans. Douglas W. Stott), Minneapolis: University of Minnesota Press, 2008.

Carl Schmitt, *Political Theology: Four Chapters on the Concept of Sovereignty* (trans. George Schwab), Chicago: University of Chicago Press, 2006.

Carl Schmitt, *The Concept of the Political* (trans. George Schwab), Chicago: University of Chicago Press, 2007.

Susan Sontag, *Against Interpretation,* New York: Dell Laurel Edition, 1969.

Romanticism David Blayney Brown

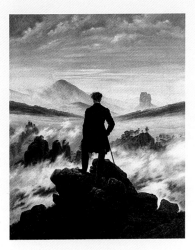

ART&IDEAS

PHAIDON

THE
IDEOLOGY
OF THE
AESTHETIC

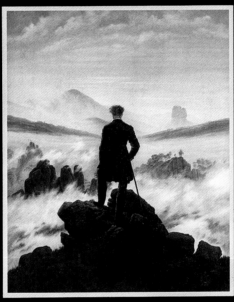

Terry Eagleton

The Birth of
the Modern

WORLD SOCIETY 1815-1830

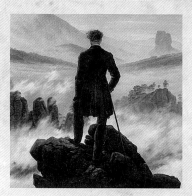

"A profoundly, persistently, maddeningly interesting
work."—Jeffrey Scheuer, *Los Angeles Times Book Review*

Paul Johnson

Author of *Modern Times* and *A History of the Jews*

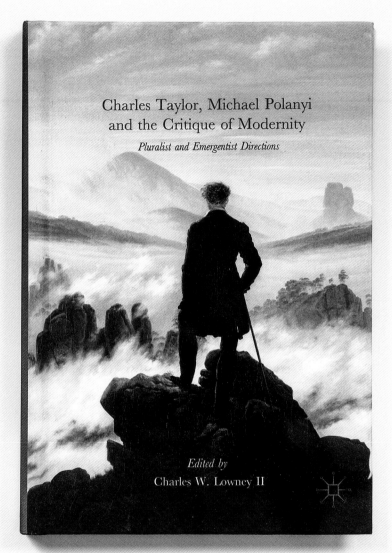

Charles Taylor, Michael Polanyi
and the Critique of Modernity

Pluralist and Emergentist Directions

Edited by
Charles W. Lowney II

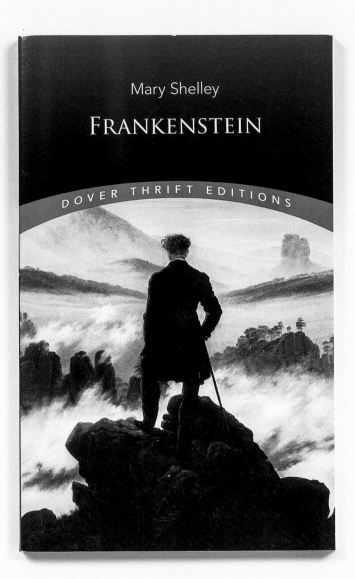

Mary Shelley

FRANKENSTEIN

DOVER THRIFT EDITIONS

THE WILL TO POWER

FRIEDRICH NIETZSCHE

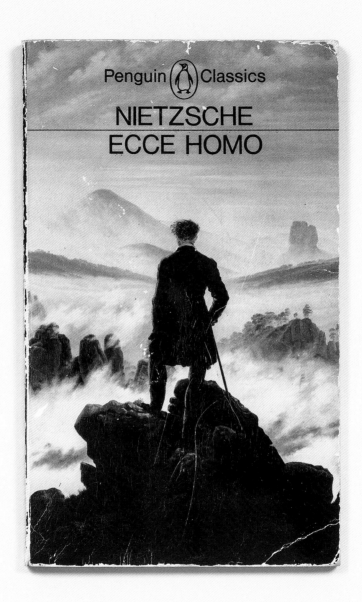

Penguin Classics

NIETZSCHE
ECCE HOMO

THUS SPOKE
ZARATHUSTRA

Friedrich Nietzsche

Introduction by Kathleen M. Higgins
and Robert C. Solomon

Translated by Clancy Martin

BARNES
&NOBLE
CLASSICS

A Sense of the World

HOW A BLIND MAN BECAME
HISTORY'S GREATEST
TRAVELER

"Brilliantly executed . . .
alive, magisterial, suspenseful.
Full of wonder and with a commanding
sense of narrative, this is one of the best
and most life-affirming biographies I've ever read."
—**Dave Eggers**

JASON ROBERTS

LORD BYRON'S
NOVEL

The Evening Land

A NOVEL BY

JOHN CROWLEY

Author of the *New York Times* Notable Book *The Translator*

OXFORD WORLD'S CLASSICS

WILKIE COLLINS
MAD MONKTON
AND OTHER STORIES

LOOKING AT
MINDFULNESS

TWENTY-
FIVE
PAINTINGS
TO

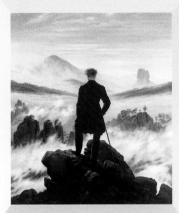

CHANGE
THE
WAY YOU
LIVE

CHRISTOPHE
ANDRÉ

"A work of art in its own right and a meditative tour de force."
—JON KABAT-ZINN, author of *Wherever You Go, There You Are*

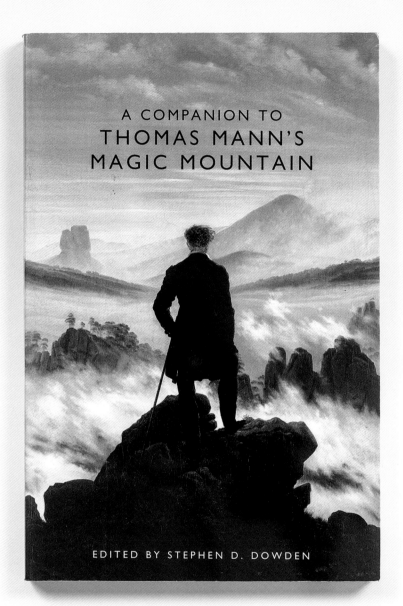

A COMPANION TO
THOMAS MANN'S
MAGIC MOUNTAIN

EDITED BY STEPHEN D. DOWDEN

OUT OF INFERNO

Strindberg's
Reawakening
as an Artist

HARRY G. CARLSON

Traveller looking over the Sea of Fog (c. 1818)

Oil on canvas, 94.8 x 74.8 cm

Hamburg, Kunsthalle

The immediate textual source is again biblical, this time from the book of Psalms. Psalm 18 was sung by David after his deliverance from Saul and makes many references to God as a "rock." Verse 2, for example, praises the lord as "my rock, and my fortress, and my deliverer... the horn of my salvation, and my high tower." And verse 46 cries out in joy, "The Lord liveth; and blessed be my rock; and let the God of my salvation be exalted." The allusion to this psalm, like a pietist sermon by Schleiermacher, states the case for eternal life and the idea of the creation of male and female in the image of God.

According to the tradition handed down by the previous owners of the picture, the traveler in the scene was one "Herr von Brincken," which best identifies Friedrich Gotthard von Brincken, a colonel in the Saxon infantry who fought on the side of Prussia during the Wars of Liberation. He stands in the mountains of his native Saxon Switzerland, looking due south towards the crest of the Rosenberg and the unusual rock formation of the Zirkelstein on the right. He himself is probably standing on the summit of the Wachtberg or Schweizerkrone, lower than the Rosenberg by nearly four hundred feet. This identification of a national hero with his native landscape, bound by the upsurge of the transcending horizon, offers a striking demonstration of Friedrich's interchangeability of the Absolute with the idea of the fatherland.

Albert Boime, *A Social History of Modern Art, vol. 2: Art in an Age of Bonapartism, 1800–1815*, Chicago: The University of Chicago Press, 1990, p. 633–634.

Overleaf: Photograph by the author

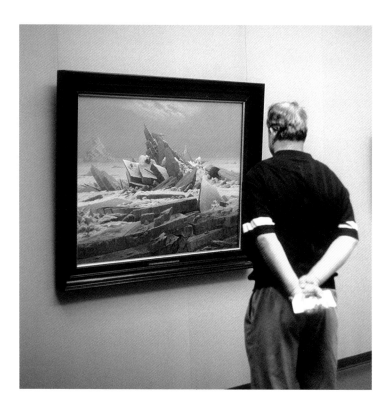

Hans Haacke

Visitor at the Kunsthalle Hamburg Contemplating

"The Wreck of Hope" by Caspar David Friedrich, 2007

When Dieter Roelstraete first shared his idea for the *Kleine Welt* publication with me, I proposed an interview with Hans Haacke, an artist whom I hold in the highest esteem and whom I knew to be a fan – just like Dieter and myself – of Caspar David Friedrich's work. I wanted to know what Hans thought about Caspar, so as to perhaps better understand both. To my delight Dieter agreed to this without hesitation. The seeming lack of an obvious connection between our work (Friedrich, Haacke, and myself) was of particular interest to me. I would posit that there exists something akin to a spirit of comradery that can occur between artists transcending time, geography, language, and maybe even something like style or form.

Dieter also told me how correspondences of this kind resonated with another leitmotif of the project, relating to the conception of the book as a letter sent to a heretofore unknown addressee. (It is in fact Peter Sloterdijk who likes to quote Jean Paul's quip that "books are thick letters to friends.")

Connections, correspondences, letters, mail (of the electronic and so-called snail variety); distances short and long; nearness; call and response; being out of one's own head and mind and being out in the world – our *kleine Welt* – with others: This is also the essence, in many ways, of my contribution to the exhibition which this publication accompanies, the *USSA Postal Service*.

I would like to thank Hans, Dieter, and Caspar for connecting and taking part in this free exchange.

– Zachary Cahill

Weathering
Zachary Cahill in Conversation with Hans Haacke

What was the first image of Caspar David Friedrich's work you ever saw? Did you see it in a book or at a museum? What did the image feel like? What about it was compelling for you?

I don't remember which image it was. I certainly did not see it in a museum. It may have been the very popular *Two Men Contemplating the Moon*. One sees the two men from the back. The one on the left appears to be the younger of the two. He has put his hand on the shoulder of his companion, like a friend or a son. They are standing on a rocky outpost. An old, half-uprooted tree with many broken branches, but some fresh green, is leaning to their right. The sickle of the moon they are gazing at is positioned in the very center of the painting and illuminates the scene. The moon, of course, is full of allegorical meanings. In the Islamic world the sickle appears on flags and other significant emblems. Many of the other details of the painting probably also have metaphoric connotations.

In Germany, Friedrich's works have been popular for well over 170 years. They have been and still are reproduced widely on calendars and in the media. It does not require higher education to know them.

But it is not generally recognized that Friedrich was a politically engaged artist. In many of his paintings one can decipher explicit references to the political events of his time. None of them celebrates a ruler or the ruling class. During the Napoleonic occupation of the German mini states – before 1871 there was no German nation – Friedrich fervently supported the war of liberation against the French, an effort not shared or even resisted by some of the German princedoms, especially by the ones that were allied with Napoleon. Friedrich did not paint battle scenes or waving flags. Like so much of Friedrich's work, his images from this period are rather melancholic. To cite just two examples: the grave of a legendary freedom fighter and a lone, lost French soldier seen in the distance on a snow-covered path in a German forest, with a raven sitting on a tree stump in the foreground.

Contrary to what Friedrich and many of his contemporaries had fervently hoped for, the defeat of Napoleon did not lead to the end of German feudalism and the introduction of the tenets of the French Revolution. Most poignantly, Friedrich expressed this disappointment in his Nordic seascape *The Wreck of Hope* of 1823–24. There, barely recognizable, are the masts and the hull of a ship buried under an immense mountain of shards of ice.

When I saw this painting at the Hamburg Kunsthalle, I was reminded of the marble floor of the German Pavilion at the Venice Biennale that I had broken up in 1993. My wrecking the floor alluded to what Hitler had done in Germany – and the world – which finally came to an end with the fall of the wall in Berlin in 1989 and, soon thereafter, the reunification of Germany. A year before Hitler invaded Poland in 1939 – the beginning of World War II – he had commissioned a Nazi architect to refashion, in Neoclassicist bombast, the old Rococo palace of the German Pavilion in Venice. I remember seeing older visitors of my "tribute" to *GERMANIA* picking up slabs of the broken floor and smashing them to the ground with passion in order to break them further. I should point

out that the visual similarity of Friedrich's shards of ice and these broken marble plates in Venice does not imply a matching allegorical meaning. The end of hope is not the same as the end of horror and the chance for a new beginning!

Caspar David Friedrich is *a* or even *the* quintessential figure of Romanticism, and you have often been cited as the father of institutional critique. So for some readers it might not be obvious why you would be a fan of his work, in so much as people often use the word "romantic" as connoting something like the opposite of the political. What do you think people misunderstand about his work? A corollary question: What do you think people might not understand about your work as it pertains to notions of Romanticism and politics?

I believe it is a mistake to think of Romanticism, and particularly of Friedrich, as being divorced from the political struggles of the times. As I mentioned, many of the figures in Friedrich's paintings are seen from the back. In effect, the viewer thus identifies with them as they are looking into the distance, be it to the moon, onto the Baltic sea toward Sweden, which had a more liberal political order than the German principalities – or to the future. I am not a scholar of Romanticism. But I believe, while German Romantics were opposed to Napoleon, they were not only striving for a unified nation but also desperately trying to end feudalism. In fact, they were inspired by the motto of the French Revolution: "Freedom, Equality, Fraternity."

Was Romanticism in any way a type of pre-modernist form of institutional critique? If so, what were the Romantics critiquing?

When we look at the world today, 225 years after the call for "Freedom, Equality, Fraternity," the promise of the French Revolution is still far from being realized. Racism,

divisive tribalism, bigotry, and horrendous inequality are rampant, including in the country that mounted a Statue of Liberty that it had received as a gift from France. The civil rights movement has not yet fully succeeded, solidarity and economic equality are not a given, and neither are gender and LGBTQ equality. The American Civil Liberties Union, Human Rights Watch, and other civic organizations cannot keep up with the threats and encroachments on basic principles of the American Constitution. Was the Occupy Wall Street movement's challenge to oligarchy in this country pursuing a romantic dream? Were the members of the Art Workers Coalition and the so-called institutional critics romantic dreamers? Are the more recent activists challenging the established art world caught in a dream world?

Caspar David Friedrich's *Wanderer Above the Sea of Fog* comes to mind. I interpret it as his reaction to the 1815 creation of the German Confederation, an illiberal order reaffirming the powers of the princes. The wanderer is a potent symbol in German lore. With bushy hair this one looks like a young man, perhaps representing one of the rebellious German students who fought Napoleon, inspired by the French Revolution. In the middle ground, rising above the fog are a few rocks that are as high as the bare spike on which the wanderer is perched. Far in the distance he – and we – see to his left the peak of a tall and expansive mountain, in the painting considerably higher than the head of the wanderer. To the right the stump of a rock matches his height in the geometry of the image. I speculate Friedrich thought it is the green mountain, a triangle, that was worth aspiring to reach, not the dead rock to his right. I don't know whether the political connotations of left and right of today already existed in 1815. Making the world a more humane environment is a long-distance goal. As we know, it takes tremendous perseverance – and a pragmatic approach! The struggle will never end, because humanity is probably not totally human. End of sermon.

Left-field question perhaps: What is the political
import of weather? It's probably too obvious to point
out that weather plays a role in almost every Caspar
David Friedrich painting, and it seems relevant to your
work as well... I am thinking of the freezing-cold show
at X-Initiative a while back. That's an actual use of
weather, but there are, of course, other examples where
weather plays a role in your work. Is weather itself (or its
representations) politically charged?

By now, it is clear to everyone – including those who deny
the threat of and, in effect, the already recognizable
consequences of climate change – that global warming is a
politically highly charged issue. Air pollution, hurricanes,
flooding, wildfires, deforestation, and drought are in the
news. A lot of money, jobs, and, of course, also many lives
are at stake.

The title of my cold show at X-Initiative in 2009
was *Weather, or Not.* One of the works included was a
thermograph and a barograph, *Recording of Climate in an
Art Exhibition.* That had been my ironic comment when it
originally did its job for me in the exhibition *Conceptual
Art and Conceptual Aspects*, which Joseph Kosuth – and
perhaps others – had put together in 1970 at the New
York Cultural Center. It was in the late 1960s that my
thinking in terms of systems – in the beginning only of
physical systems – expanded to include biological and then
also social systems. It goes without saying, they are all
interconnected.

Already in the early 1960s, I used light, heat and
cold, air movements, and environmental humidity as active
elements in my works. For an outdoor exhibition in a dry
forest near Saint-Paul-de-Vence in the South of France, I
created an artificial climate for the survival of moss that I
had imported to the site. While weather is not the dominant
aspect of my installation *DER BEVÖLKERUNG* (To
the Population) in the northern open-air courtyard of
the Reichstag, the German Parliament building in Berlin,

inevitably, it plays a role there. Since the year 2000 MPs have been invited to bring 200 pounds of soil from their election districts to a trough in that courtyard. Seeds that are often embedded in the soil have sprouted and, over many years, have produced a wild, untended vegetation, with bushes and even a chestnut tree that now rises to the height of the second floor of the Reichstag. Since the courtyard is open to the sky, one sees blooms in the spring, it is very green in the summer, the leaves wilt in the fall, and the courtyard is covered under snow in the winter. Snails that I saw on tree branches do survive the changes of the weather.

Zachary Cahill

View from Barr'd Islands, 2018

Watercolor on paper

Zachary Cahill

Sunset at Brimstone Head, 2018

Watercolor on paper

Zachary Cahill
Fogo Island Post Office, 2018
Watercolor on paper

Zachary Cahill

Sunrise on the Bay at Joe Batt's Arm, 2018

Watercolor on paper

David Schutter
Drawing Boards (installation view), 2019
Woodcut

During a recent visit to the Alte Nationalgalerie in Berlin, David Schutter noted the frequent occurrence of birch trees in the work of Caspar David Friedrich. As given as the oak tree in Friedrich's *oeuvre*, the birch tree is its natural antithesis: slight, fragile, and short-lived. After returning to his Chicago studio, Schutter began work on a series of drawings based on Friedrich's birches executed on his own well-worn birch drawing boards. As with any drawing the artist makes on these soft birch panels, faint impressions remain embossed on the board underneath. In between drawings, Schutter habitually brushes back the impressions with a wire brush, returning the wood to a fresh flatness for each new drawing. *Drawing Boards* consists of a pair of the artist's birch drawing panels printed in the German woodcutting tradition. While there are no "cuts" incised in the wood, and the last impressions of his many Friedrich birch tree drawings have been erased through a final wire brushing, what remains as relief is the opposite of a conventional palimpsest in the manner of Sigmund Freud's famed "Mystic Writing Pad." The blank, yet loaded historical surfaces of the birch drawing boards appear at the margins of what Walter Benjamin defined as the aura of originality, of the origin of the work of art.

With these woodcuts, Schutter also exposes the brutal material regime of the birch boards' industrial production – a nod, perhaps, to the artist's conscious distancing from Friedrich's world. Unseen phenomena are perceptible in the prints – a hew of joinery, the lines laid through machine planing, the distress of Schutter's ritual handling, and the prominence of the wood's grain. The diptych is printed in the birch tree's distinctive black and white, each panel offering singular haptic and visual reflections that together form an impossible composite.

A recurring aspect of Schutter's practice is his determined reluctance to make works that can be easily reproduced, most markedly so in his painterly work. The black half of *Drawing Boards* is legible to the eye, its surface texture still somewhat discernible from a distance. Its white counterpart, however, can only be grasped as a kind of anamorphic image. By craning our neck or cocking our head to see it, the white print's impression yields only a momentary flash of its presence, rendering perception a thing forever problematized by memory.

David Schutter
Drawing Boards, 2019
Woodcut

Colophon

This book was published on
the occasion of the exhibition

Kleine Welt
Neubauer Collegium
for Culture and Society
University of Chicago
January 17 – April 6, 2019
Curated by Dieter Roelstraete

Editor
Dieter Roelstraete

Managing Editor
Mark Sorkin

Design
David Khan-Giordano

Color management
Professional Graphics

Printed in Lithuania by BALTO

ISBN 978-0-578-45954-7
© 2019 The University of Chicago.
Texts © the authors. All rights reserved.
No part of this book may be reproduced
or transmitted in any manner without
prior written permission from the
copyright holders and publisher.
For information, please contact:
Neubauer Collegium for Culture and
Society at the University of Chicago, 5701
S. Woodlawn Ave., Chicago, IL 60637.

Support for the exhibition and publication
comes from the Brenda Mulmed Shapiro
Fund at the Neubauer Collegium for
Culture and Society.

Image credits

Cover
Paul Klee, *Little World (Kleine Welt)*, 1918.
Photo © 2018 courtesy of The David
and Alfred Smart Museum of Art,
University of Chicago.

p. 4; pp. 162–165
© David Schutter
Photographer: Robert Chase Heishman

pp. 14–94; pp. 132–146
© Assaf Evron

pp. 103–105
© R. H. Quaytman

p. 112; p. 148
© Dieter Roelstraete

p. 150
© Hans Haacke / Artists Rights Society,
New York

pp. 158–161
© Zachary Cahill